IMAGES
of America

PAWLING

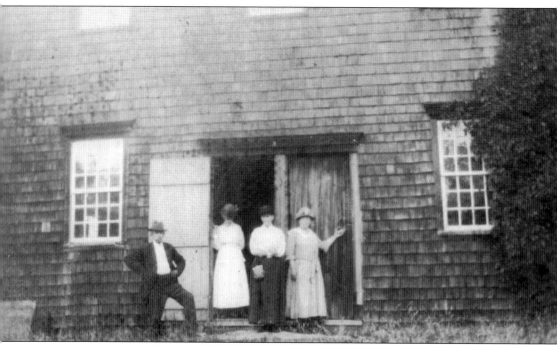

The Oblong Meetinghouse was originally built in 1742 for the Society of Friends and was located across the street from where it sits today. In 1763, it became clear that, thanks to growing membership within the society, the original structure would be too small to hold the whole congregation for many more years. The congregation requested funds from the council at the quarterly meeting to construct a brick structure 45 by 35 feet in dimensions. The council issued that the building shall be 45 by 40 feet in dimensions and made of hewn timber. Whether as a church for the Quakers or a hospital for Patriots, the building is one of Pawling's most treasured. The individuals are unidentified. (Courtesy of the Akin Free Library.)

ON THE COVER: The Mizzentop Firehouse was located on Quaker Hill. Fire chief David Patchey is standing to the far right. He served two terms as chief (1975–1976 and 1998–1999). This photograph was taken during his first term. The land upon which the fire department built this station was donated to the town by Dr. Norman Vincent Peale and his wife, Ruth Stafford Peale. At the dedication ceremony, Chief Patchey presented to Dr. Peale a Pawling Fire Department chaplain's helmet, made especially for him. (Courtesy of the Peale History Center and Library.)

IMAGES
of America

PAWLING

Max Weber

ARCADIA
PUBLISHING

Published by Arcadia Publishing
Charleston, South Carolina

Printed in the United States of America

Library of Congress Control Number: 2019939611

For all general information, please contact Arcadia Publishing:
Telephone 843-853-2070
Fax 843-853-0044
E-mail sales@arcadiapublishing.com
For customer service and orders:
Toll-Free 1-888-313-2665

Visit us on the Internet at www.arcadiapublishing.com

This work is dedicated to Chuck Werner, without whom this book could not have been written.

CONTENTS

Acknowledgments 6

Introduction 7

1. Settling the Territory and the Revolutionary War 9

2. Agrarian Roots with Cosmopolitan Ambitions 29

3. A Small Town on the Road to the White House 53

4. The 20th Century in Pawling 71

Bibliography 127

ACKNOWLEDGMENTS

This book could not have been written without the support of the town and its valued friends and residents—most notably Gregg Sheridan, Mark Bailey, and Earl Slocum, whose knowledge of the town and its history is without equal. Thank you for sharing your stories and your photographs. I could not have completed this work without the contributions of the Akin Free Library and its director, Matt Hogan. The Historical Society of Quaker Hill and Pawling, especially its tireless member John Brockway, was an invaluable partner. The Peale History Center and Library's archivist George Hart and Elizabeth Allen were incredibly helpful and knowledgeable, and so was the Trinity-Pawling School archivist Megan Burlington, whose enthusiasm for history is a local treasure. I also could not have done this without the Book Cove and its manager—and more importantly my friend—Tara Lombardozzi, who provided incalculable guidance in acquiring authorities on Pawling. My friends Ed and Mary Mahaffey, Nancy Clark Tanner, Donald Utter, Verna Carey, Charlotte Whaley, Mike Clark, Margaret Hubert, Robert and Nancy Reilly, Marie Stewart, and Ross Daniels, thank you for all for your assistance, eagerness, and zeal for this work and the town. A note of personal thanks is necessary to bestow upon Jean Weber for selecting this beautiful town to raise her family.

INTRODUCTION

The history of the town we know as Pawling begins with Native Americans known as the Mohicans. Historians are sure of their presence because of the existence of two burial grounds in the area. Though it was probably not a large settlement, it provided excellent means of subsistence especially around Whaley Lake. Once European settlers began to approach the area, it is believed that the interactions between the settlers and Mohicans were peaceful. This was made possible because the Society of Friends (Quakers) valued coexistence and were not interested in condemning the native people of the area. The Quakers' predisposition toward peaceful coexistence naturally extended to the Native Americans.

Once the Quakers established a community in Pawling, more and more people moved to the area. The names of these people can still be seen around town on signs, maps, and even mailboxes. These settlers could not have imagined that their progeny would still be in the area some 220 years later. Among the earliest records are the names Birdsall, Slocum, Utter, Cary, Hunt, Dodge, and Pearce.

The town of Pawling was formed out of different precincts that existed as names on a map more than anything. The Beekman territory, which extended farther south, was divided to give Pawling its land and some of its boundaries, which are still observed today. The Pawling territory would see subtractions in its square mileage, especially to the north, where Dover carved for itself an independent town in the 1780s. The area at the time of George Washington's visit was referred to as Fredericksburg. The area of Fredericksburg was much larger than Pawling is today, and it encompassed the neighboring towns of Patterson, Holmes, Carmel, and Kent.

The growth and prosperity of the town were foreseen by few people. However, some, like Albert Akin, knew that for Pawling to be on the map, it needed to be connected to the world around it. Akin worked to bring the railroad to the heart of the village so that farmers in the area would have a larger customer base for their goods. He also knew the natural beauty would attract people from crowded cities to relax. He built a grand hotel at the top of Quaker Hill and encouraged people to enjoy the marvelous view. It is still in many ways Akin's town that we have to enjoy for ourselves.

An interesting alternative history could have been written during the 20th century. It was during this time when our own Thomas E. Dewey ran for president on the Republican ticket. Had he won, Pawling might have had a presidential library, museum, tour, and at the very least, a T-shirt with his face and the town's name.

Fame was not as relative as it has become in our own time; it was not an adjective to describe as many people as it is today. That said, Pawling had an unusually large number of well-known residents. Lowell Thomas, Edward R. Murrow, and Norman Vincent Peale shaped the country from a little town called Pawling. Governor Dewey hosted Eisenhower, Nixon, Roosevelt, and Hoover on Quaker Hill.

This book has been written to introduce the reader to our beautiful area. As a bookseller, I cannot count how many times I have been asked if there is a book on Pawling's history. Some wonderful volumes have been written about our area before, and sadly, they are not in print any longer. They are difficult to come by, as families typically do not part with them, choosing to keep them in the family instead. It is my hope that this book sparks interest in Pawling and makes the reader search out more about its bygone times.

One

SETTLING THE TERRITORY AND THE REVOLUTIONARY WAR

If anything were to predestine Pawling for greatness, it would have to be the arrival of Gen. George Washington. In 1778, one year after the soul-crushing winter at Valley Forge, General Washington arrived with his troops and took up residence in the town. He spent his time between the Reed Ferris House on Quaker Hill and the John Kane House in the village. The John Kane House still stands as a monument to the history the town made on the national stage.

General Washington spent three months in Pawling, and it was not a quiet winter encampment. It was here that he celebrated the one-year anniversary of the surrender of Gen. "Gentleman Johnny" Burgoyne—an occasion he used to raise the morale of the troops by staging a great barbecue feast. For many years after, Pawling would host a "great barbecue" to recognize the precedent General Washington had set. It was on Quaker Hill that the military tribunal for Gen. Philip Schuyler deliberated and eventually acquitted him on every charge. Many generals of the Continental Army would pass through the area's wooded glens and rolling hills.

It is a strange anomaly that more than most of the many historical texts written about the Revolutionary War neglect to mention the three-month period Gen. George Washington spent in the area. When Alexander Hamilton's father-in-law, Philip Schuyler, was put on trial and found not guilty of using the soldiers under his command to further his own glory and fortunes, the town hosted such notables as the Marquis de Lafayette and chief artillery officer Henry Knox. Even though the court-martial was requested by General Schuyler, and he was found without guilt by his peers, he resigned from the Army and returned to the Continental Congress.

Gen. George Washington was convinced that the winner of the War for Independence would obviously be the side that controlled the Hudson River valley. With New York City to the south and the fortress at West Point to the north, the area provided security and vast resources to draw upon. The Hudson River would become the home of the most important chevaux-de-frise in history. Today, it is referred to as the Great Chain of the Hudson River.

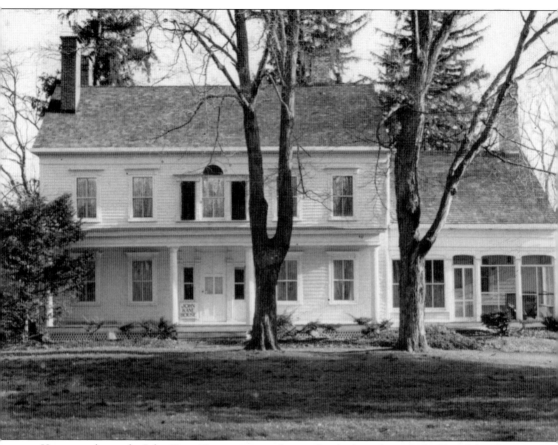

Known today as the John Kane House, its significance has little to do with the Tory John Kane. It was General Washington's headquarters for the months of September to November, 1778. During this time, many notable events took place in Pawling, such as the court-martial and acquittal of Gen. Philip Schuyler and the first anniversary of the defeat of British general "Gentleman Johnny" Burgoyne at Saratoga. General Washington held a great barbecue on the one-year anniversary of that historic defeat. (Courtesy of the Akin Free Library.)

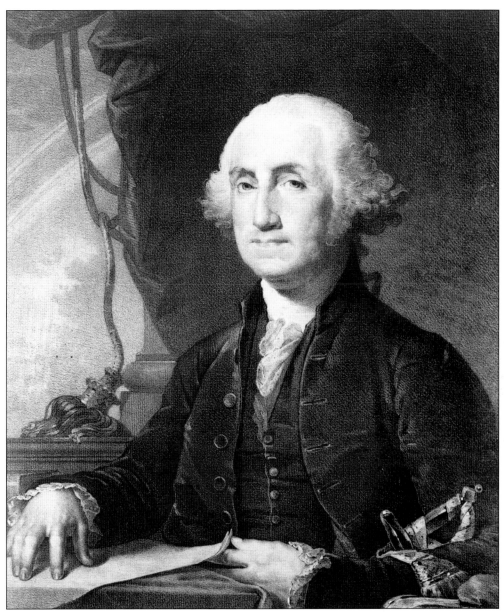

Leader of the Continental Army Gen. George Washington resided in Pawling for three months during the Revolutionary War. The proximity to New York City was a key factor in his decision to set up camp within the town. He would spend his time between the John Kane House and the long-gone Reed Ferris House. Most of his soldiers were encamped upon Purgatory Hill. The court-martial of Maj. Gen. Philip Schuyler, which Washington presided over, was held at the home of Reed Ferris and lasted three days. The Marquis de Lafayette personally delivered the not guilty verdict to Congress. (Courtesy of the Library of Congress.)

This photograph is of one of the earlier Slocum homesteads. This residence was on Elm Street and housed two generations of the Slocum family, including Allen Slocum and his wife, Dorothy, and E. Munn Slocum and his wife, Christina. The Slocums also owned property on Walnut Street. (Courtesy of Earl Slocum.)

This photograph of Quaker Hill was taken in the 1800s. Today, it is the site of the Akin Free Library and Quaker Hill Museum. In the distance is the Wheeler House. (Courtesy of the Akin Free Library.)

Harriet Taber Akin is seen here towards the end of her life. Born in 1801, she lived to be 79 years old. Her parents were Jeremiah Taber and Delalah Russell. She would marry Jonathan Akin II and have four children with him. She is buried in Pawling Cemetery. (Courtesy of the Akin Free Library.)

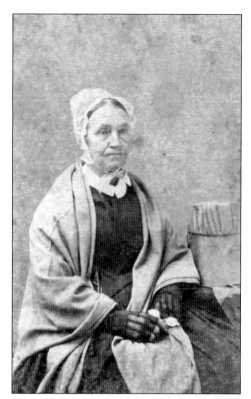

In observation of their faith, members of the Society of Friends entered the meetinghouse via gender-specific doors. The left door was for men, and the women seen here inside the meetinghouse would have had to enter through the right. A partition could be raised or lowered into place along the center of the room to allow separate business to occur. It was always raised to allow joint participation in the twice-weekly worship at the meetinghouse. The nails used in constructing of the meetinghouse were hand wrought by artisans at blacksmith shops in the local vicinity. The wooden pegs used to join the boards were likewise whittled by hand. Its roof was covered in wooden shingles about 27 inches long but only exposed about one inch at the end. (Courtesy of Don Utter.)

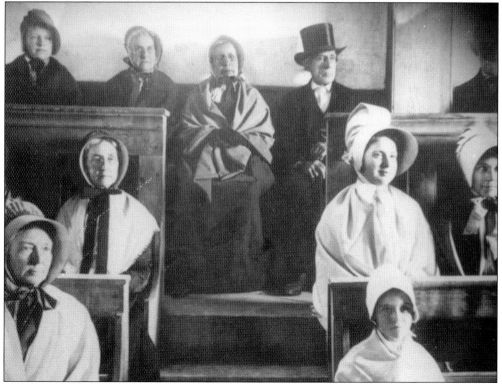

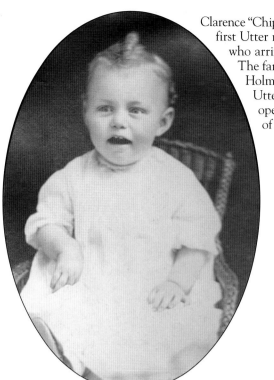

Clarence "Chip" Utter, pictured here, was born in 1918. The first Utter recorded in the town was Benjamin Utter, who arrived in the Pawling area in the late 1700s. The farming family has always lived in Pawling or Holmes since the time of the Revolutionary War. Utter Brothers Feed Supply on Charles Street is operated by the sons of Chip Utter. (Courtesy of Don Utter.)

Maggie Lynch Slocum was the wife of Alexander A. Slocum. She lived on Elm Street with her husband and five children. She had two sons, E. Munn and Allen, and three daughters, Birdella, Mina, and Ada. (Courtesy of Steve Walsh.)

The very first constable in the town of Pawling was Alexander A. Slocum. The youngest son of George and Polly Mulkins Slocum, he lived to be 66 years old, and while on earth, he was an invaluable resident. His responsibilities as the constable included cleaning and refueling streetlamps. His workday began at 7:00 a.m. and concluded at 9:00 p.m. The Slocums became known for their mechanic shop after Alexander opened it to the great benefit of the town. It was here Pawling residents could refill their tank, enjoy the bowling alley he had out back, or buy a used car. His cause of death was listed as a result from shock. (Courtesy of Steve Walsh.)

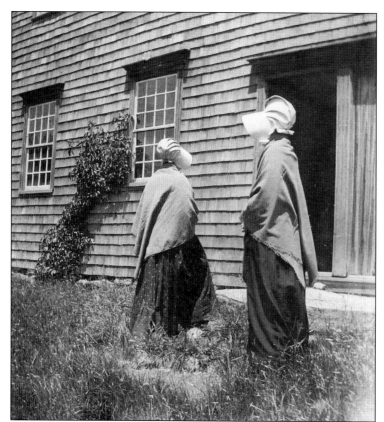

Before white settlers arrived in 1728, the area of Pawling was cultivated by the Wappinger Native Americans. By 1778, they had lost their last chieftain and moved on. The Oblong Meetinghouse that still stands today was built in 1764. It replaced an earlier structure built in 1742 in the same general area. Even though it was against the pacifist beliefs of its members, the Oblong Meetinghouse was notably used as a hospital during the Revolutionary War. (Courtesy of the Akin Free Library.)

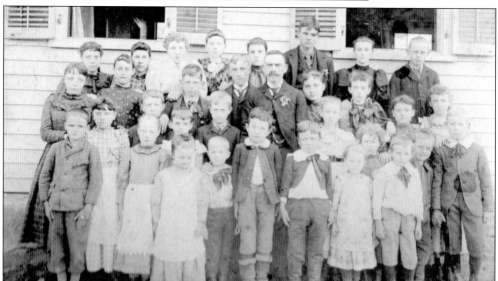

The hamlet of Holmes has been known by different names throughout the centuries. It was first known as Campbell's Creek, followed by Reynoldsville, and finally Holmes. This photograph of the Reynoldsville Schoolhouse was taken around 1895. Pawling and Holmes both had their own school system at this time independent of the other. The Pawling Union Free School was larger, with a class of 143 students (all ages) and 5 teachers. (Courtesy of the Akin Free Library.)

Ann Toffey Hayes was the postmistress of Quaker Hill for over 40 years. She was known as "Aunt Ann" by everyone in the town. Hayes is seen here with her great-niece Annie Thomas. Toffey married John Hayes, a tailor by trade, in 1849. Her mother, Esther Toffey, was known for her brilliance and her poetry. Ann passed away in 1906. (Courtesy of the Akin Free Library.)

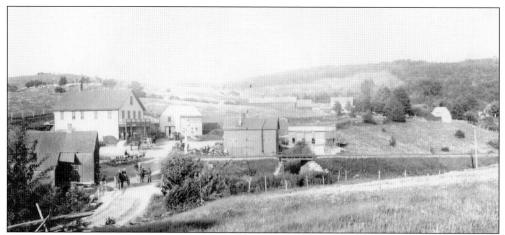

Holmes has always been an integral part of the town of Pawling. It is home to the oldest Baptist church in New York State, which was founded in 1754. It was followed by the Holmes United Methodist Church, which was founded in 1766. (Courtesy of Nancy Clark Tanner.)

Possibly before even the Quakers arrived in Pawling, the Dibbles were one of the earliest families to settle in Holmes. They first lived in the vicinity of Whaley Lake, which was where trappers usually took advantage of the abundant wildlife. The family pictured here lived on what is today known as Route 292 in Holmes. (Courtesy of the Akin Free Library.)

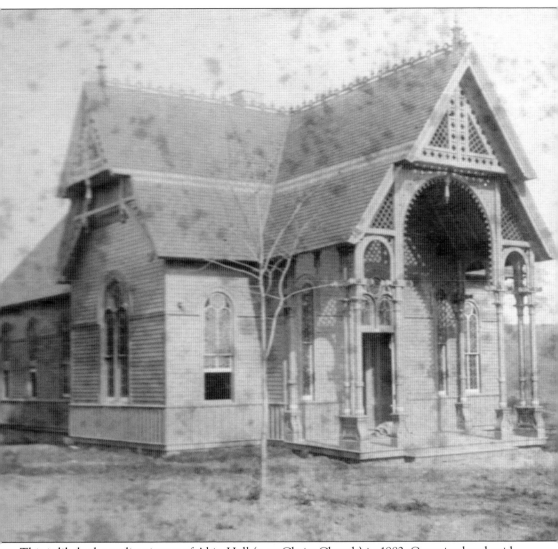

This is likely the earliest image of Akin Hall (now Christ Church) in 1882. Conceived and paid for by Albert Akin, it would become a landmark on Quaker Hill for generations. Akin Hall was constructed to provide the community a center for church services, educational lectures, and entertainment. Architect J.A. Wood of New York City designed the building. (Courtesy of Akin Free Library.)

Allen Slocum would often pick up and deliver goods for the local merchants and townspeople in Pawling to help his family earn money. He is pictured here on Elm Street at about 17 years old. (Courtesy of Steve Walsh.)

Chip Utter would live on his family's farm for his full 84 years. In this photograph, he is about 17 years old and walking along Harmony Road. He would eventually open Utter Brothers Feed Supply in the village with his brother Ken. He was the son of James and Louise Utter. (Courtesy of Donald Utter.)

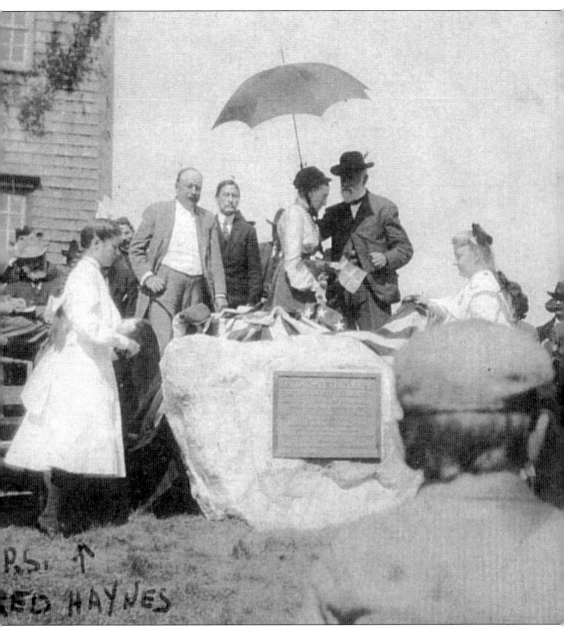

The plate affixed to the stone states that the "first effective action against slavery was taken here in 1767." The Society of Friends was quick to ban the selling and purchasing of human beings. In the decade that followed, the Society of Friends would only pass more stringent rules, eventually banning members who retained their human property. (Courtesy of the Akin Free Library.)

The Akin Free Library was constructed over a period of 10 years. Upon completion in 1908, the Reverend Warren Wilson was appointed to be the first librarian. It was designed by the same architect who envisioned the Mizzen-Top Hotel and Akin Hall. It boasted around 3,000 books and was greatly appreciated by the townspeople and guests staying at the nearby Mizzen-Top Hotel. (Courtesy of the Akin Free Library.)

Albert Akin, seen here seated outside of the Akin Free Library, was the greatest visionary of his time in Pawling. His family came from Aberdeen, Scotland, and arrived in North America around 1680. Albert John Akin was born on August 14, 1803. His father, Albro Akin, was a county judge and a leading merchant. Albert was a tireless worker who spent years in New York City as a clerk for a dry goods house and developed a career in the mercantile business. After Albert's health prematurely deteriorated, he returned to Pawling with his wife, Jane Williams, whom he met in New York City. From Quaker Hill, he redesigned the town and brought about its greatest addition, the railroad. He raised the necessary funds to extend the railroad to the town and on to Dover Plains. His railroad was only the first step in his plan. The Mizzen-Top Hotel, Akin Free Library, and Akin Hall were all constructed to bring people to Pawling and ensure its prosperity. (Courtesy of the Akin Free Library.)

The Mizzen-Top Hotel of Quaker Hill was, for a time, one of the most fashionable hotels in New York State. It was built with the financial backing of Albert Akin and John Dutcher, and architect J.A. Wood broke ground in September 1880. Construction was completed only 10 months later. With 128 rooms for visitors, and 145 rooms in total, it boasted the most fashionable amusements,

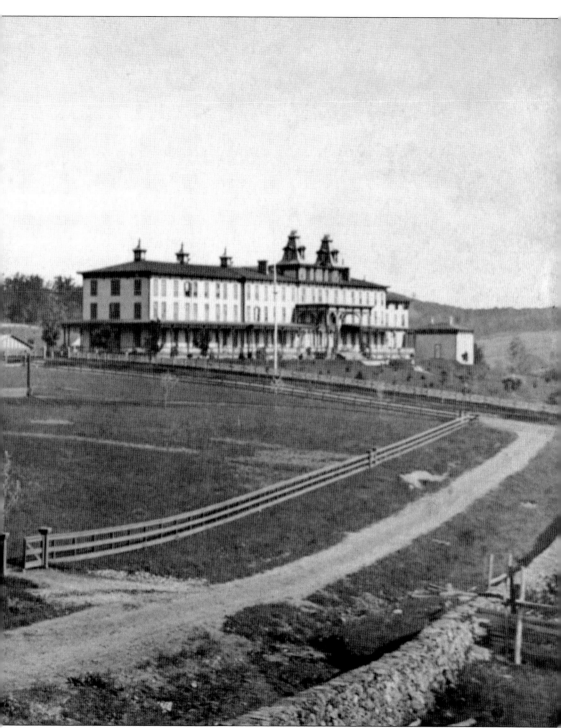

such as steam-heated bathrooms, billiard rooms, and a bowling alley, and was even connected to New York City via telegraph. The first person to sign the guest book was Admiral Worden. (Courtesy of the Akin Free Library.)

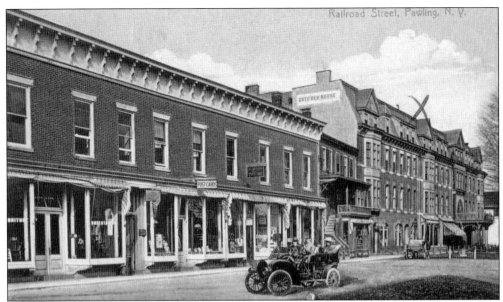

The Dutcher House, pictured in this c. 1913 postcard, was built in 1884 by John B. Dutcher. It boasted running water, gas lighting, and steam heating. It was the most convenient hotel for people traveling between New York City and Albany. John B. Dutcher knew that the hotel would be a natural draw for passengers using the railroad. It was not only a luxury for travelers but also a gift to the town. It originally housed a library, a public reading room, and a lecture room where local officials could hold meetings. (Courtesy of Charles Werner.)

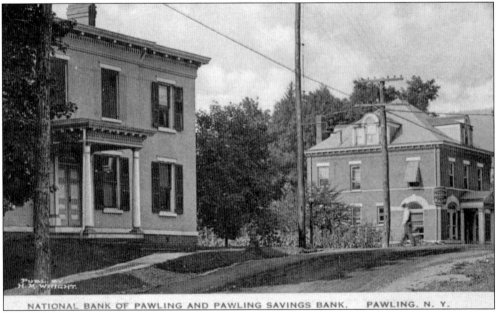

NATIONAL BANK OF PAWLING AND PAWLING SAVINGS BANK. PAWLING. N. Y.

The National Bank of Pawling and the Pawling Savings Bank were situated on West Main Street. Like most institutions established at this time, the Pawling Savings Bank was created with the help of Albert Akin. The bank was chartered on May 7, 1870, and David R. Gould was elected to be the first president of the bank. The deposits recorded on the first day totaled $632. Pawling had a population of about 1,760 at this time. (Courtesy of the Akin Free Library.)

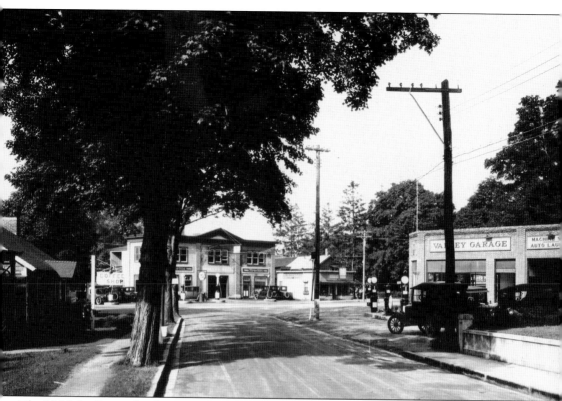

The McNulty Garage has been torn down to create what has become the Main House. On the front of the building were advertisements for state-of-the-art Firestone "Tube Tires." Across the street was Valley Garage and Machine Foundry, which is the home of Pawling Public Radio today. (Courtesy of the Akin Free Library.)

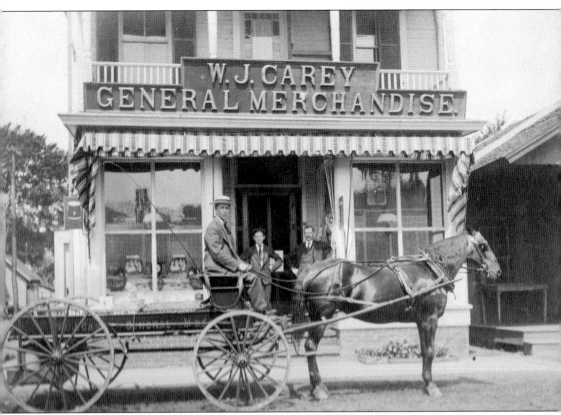

The W.J. Carey General Merchandise store opened for business on December 5, 1888. This c. 1896 photograph depicts William J. Carey in a horse-drawn wagon and two unidentified men standing in the doorway. Carey's family arrived in America from Ireland in the 1850s. The Carey General Merchandise store would move to multiple locations in the village and grow to become a staple of the community, selling groceries, candy, cigars, and household supplies. W.J. Carey married Catherine Lehan of Pawling. (Courtesy of Verna Carey.)

Two

AGRARIAN ROOTS WITH COSMOPOLITAN AMBITIONS

The 1800s was a transformative century for Pawling. It was during this time that it evolved from a Quaker settlement to a destination spot. Visionaries such as Albert Akin and John Dutcher invested and created a town that could support and create growth among its inhabitants. The building of the railroad was of the greatest importance to the town, both economically and competitively. Advertisements and publications would even refer to the town as Pawling Station, indicative of just how integral the railroad was.

The town boasted the greatest architecture in the county. Its hotels offered every amenity and luxury possible at the time. Visitors could relax and enjoy the scenic beauty of the area while hiking, fishing, canoeing, golfing, skiing, or horseback riding. When the Mizzen-Top Hotel opened up, the first person to sign the guest register was Rear Adm. John Lorimer Worden, commander of the USS *Monitor* during the Civil War.

Pawling's reputation as the Hudson Valley's best-kept secret was not created during this time period. Pawling was more like the mecca of Dutchess County. It lured the wealthy from New York City to relax among its wooded glens and hills. The plentiful farms in the area sent shipments of corn, fruit, vegetables, hay, and milk daily to market in New York City. If it were not for its residents, Pawling could have easily slipped from the spotlight. If the railroad had bypassed the town, its growth could not have been possible.

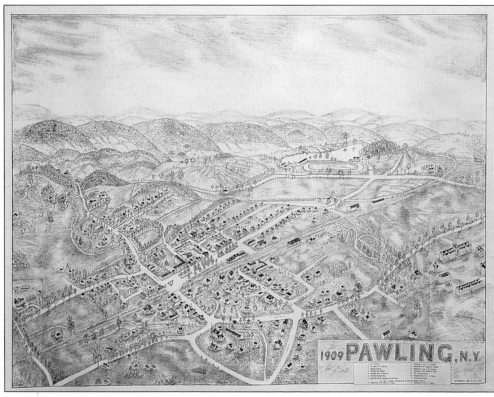

Philip H. Smith's drawing provides a bird's-eye view of how Pawling is beautifully nestled in the hills. The key in the corner lists the most notable landmarks in the town at the time. Of particular note is the racetrack located in what is now Lakeside Park. Horse races were a popular pastime in Pawling and would attract the whole town. (Courtesy of Earl Slocum.)

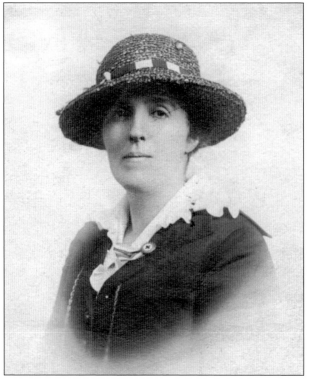

Annie M. Thomas was born in Sherman, Connecticut, in 1877. She was the daughter of Susan Ludington and John Thomas. She became a nurse and worked in New York City at Presbyterian Hospital. She was named after her aunt Ann, the postmistress of Quaker Hill. (Courtesy of the Akin Free Library.)

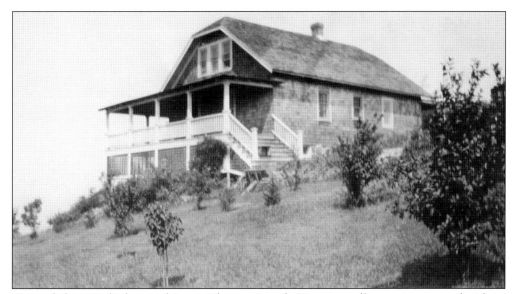

Pictured above is the home of Annie Thomas, Mostly View. Its walls were constructed with its future guests in mind. Thomas welcomed many a road-weary traveler to rest at Mostly View. She hoped that the clear skies and the dark green flora surrounding the retreat would refresh her visitors. Thomas concerned herself with the care and rehabilitation of her fellow women. When culture and traditions did not afford her gender all the rights they would grow up with today, Thomas was there to extend all she had to offer for others. It is unclear just how many women she helped in their hour of need, but her foresight to the blight of inequality in society should be recognized. (Courtesy of the Akin Free Library.)

Holmes Station was on the Maybrook Line of the railroad. From Holmes, passengers could travel to Poughkeepsie, Brewster, and Danbury. The line was being phased out for years and was completely shut down after the Poughkeepsie Railroad Bridge fire in 1974. For the greater part of the 1900s, it was used for transporting goods, not people. (Courtesy of Mark Bailey.)

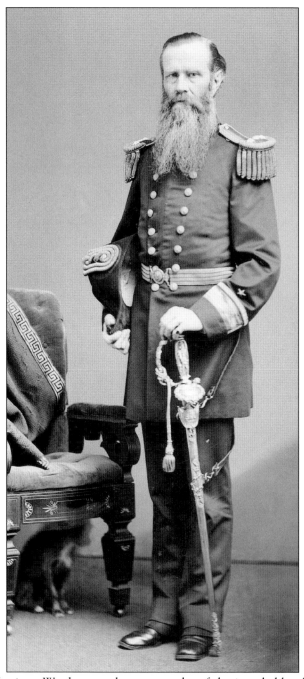

Rear Adm. John Lorimer Worden was the commander of the ironclad battleship *Monitor*. He was wounded during the Battle of the Ironclads when he engaged the Confederate ship CSS *Virginia*. Though the three-hour-long battle resulted in a draw, he was promoted afterwards. His last engagement during the Civil War was aboard the ironclad *Montauk*, participating in the naval blockade of Charleston. He married Olivia Toffey and lived on Quaker Hill with their four children. He now rests in the Pawling Rural Cemetery. (Courtesy of the Historical Society of Quaker Hill and Pawling.)

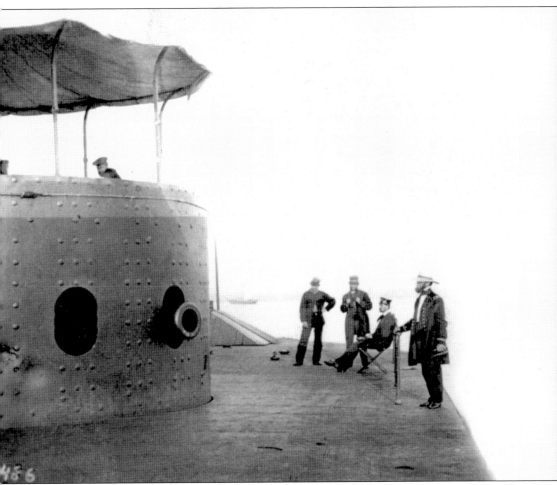

This photograph was taken on the deck of the USS *Monitor*, the first ironclad ship commissioned by the US government. It was charged with protecting the North's blockading force in the South during the Battle of Hampton Roads, more commonly known as the Battle of the Ironclads. (Courtesy of the Historical Society of Quaker Hill and Pawling.)

WHALEY LAKE. PAWLING, N. Y

It has been lost to time exactly when Whaley Lake was first named. The Whaley family has lived in Pawling for generations, and family members no longer recall why the lake is named after them. The lake was invaluable to fur trappers and mountain men who used the area for their livelihood. It would also be used for large-scale Baptisms in the 1800s. (Courtesy of Mark Bailey.)

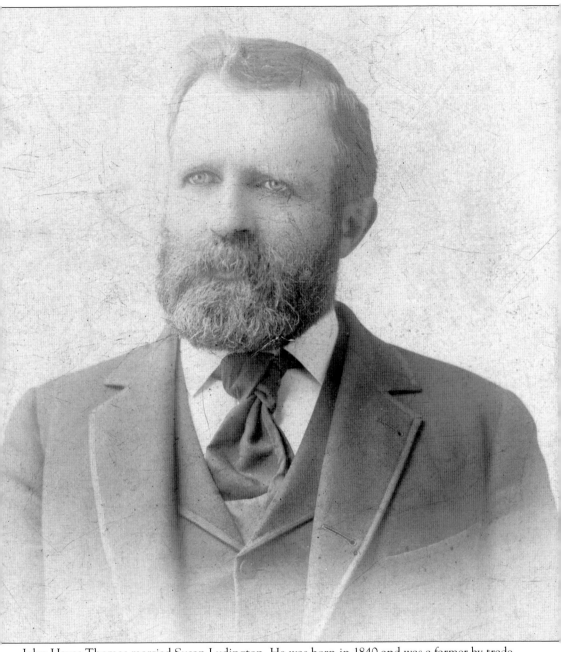

John Hayes Thomas married Susan Ludington. He was born in 1840 and was a farmer by trade. (Courtesy of the Akin Free Library.)

The homestead and farm of Charles R. Burr was located in the town of Pawling. This c. 1890 photograph depicts Dewitt and Harriet Burr with their daughter Nella. The home stood in what is now Murrow Park. It was purchased from the Burrs in 1964, and the 72-acre farm began to turn into a public park. (Courtesy of Nancy Clark Tanner.)

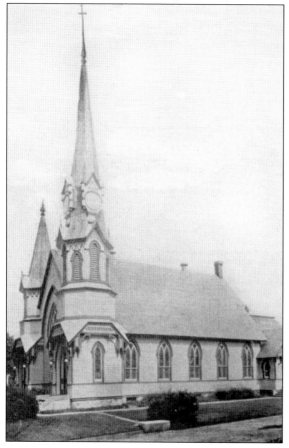

A Baptist church in the village of Pawling was organized in 1852, and the first building went up in 1853. A fire in June 1879 would destroy most of the original building, but repairs were quick, and the current building was dedicated in 1880. John Dutcher would donate the bell to the congregation. (Courtesy of the Historical Society of Quaker Hill and Pawling.)

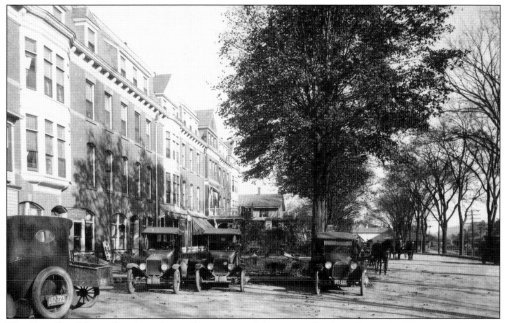

The Dutcher House has long been the center of the town. In this photograph, a sign advertises the US Post Office available inside the building. It was the most convenient place to send and receive telegrams in the area. Charles Colman Boulevard was paved in 1922. Before it was named for Charles Colman, it was known as Maple Boulevard. (Courtesy of the Akin Free Library.)

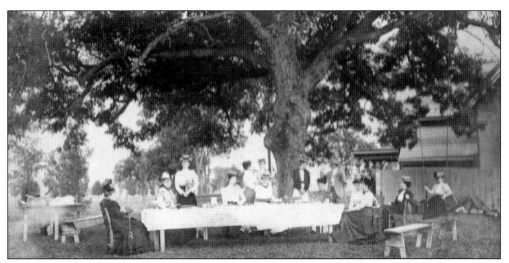

Lakeside Park has had many different purposes over the years. It would offer seasonal festivals, fishing contests, horse racing, and of course picnicking. Pictured here are, from left to right, Mrs. Taber, Mary Pugsley, Edith Gillies, Beth Cole, Gertrude Haviland, Bella Smith, Harriet Taber, Mary F. Taber, Caddy Pugsley, Howard Fox, Florence Haviland, Martha Taber, Hannah Taber, and Grace Bangs. (Courtesy of the Akin Free Library.)

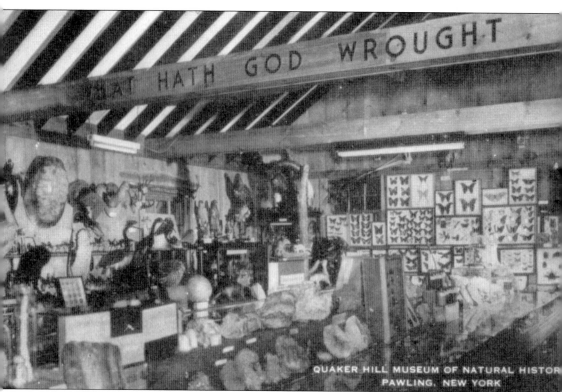

Before the Quaker Hill Museum of Natural History was housed in the lowest floor of the Akin Library, it was the collection of Olive Gunnison; she was a woman with never-ending curiosity. Her hobbies included zoology, botany, entomology, meteorology, and geology. Her exhibits were first displayed in the living room of her house. Her incredibly varied collection would eventually grow to include many taxidermy animals (over 200 birds), a shrunken head (donated anonymously), and a few preserved fetuses (both animal and human). When it became too much for the living room, Ralph Gunnison asked that the "Chamber of Horrors," as he called it, be moved to a new location. (Courtesy of the Historical Society of Quaker Hill and Pawling.)

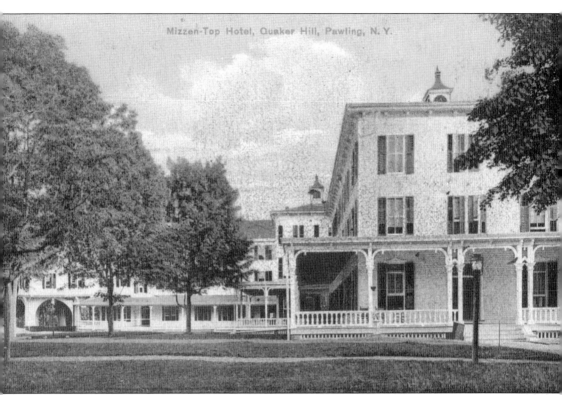

The Mizzen-Top Hotel occupied the land that now boasts the Christ Church on Quaker Hill. It was demolished in 1934 after the Great Depression greatly limited the public's ability to vacation. Built by Albert Akin in 1881, it was a high-class mountain resort for the wealthy. Boasting accessibility from New York City was of the greatest importance. Also on the grounds were four private cottages that could be rented. Boasting spectacular views and the freshest foodstuffs, it was without comparison in Dutchess County for splendor. This postcard dates back to around 1912. (Courtesy of Charles Werner.)

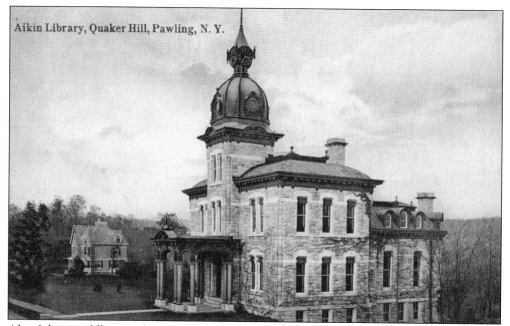

Akin Library, oddly enough misspelled Aikin on the front of this postcard, is open on weekends from April to November. The Gunnison Collection encompasses the bottom floor of the library. (Courtesy of the Historical Society of Quaker Hill and Pawling.)

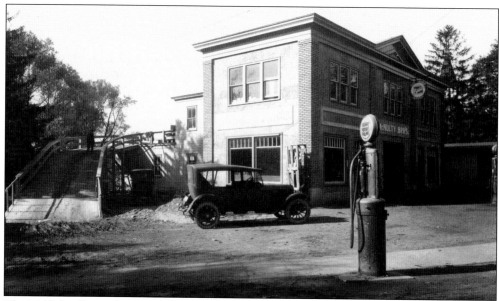

The McNulty Garage became Riley's Garage in 1972. Thanks to the ramp, cars could be repaired on both the first and second floors. Before it was run by the McNultys, it was the Forschner Bros. Garage and auto supply store. (Courtesy of the Akin Free Library.)

40

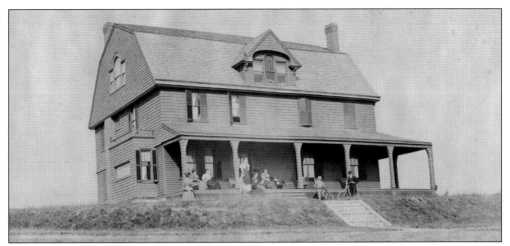

In the 1890s, Margaret Monahan ran the Hill Hope House and what was known as the Fresh Air Girls. The girls, mostly residents of New York City would travel to Pawling to recuperate from various ills such as nervousness and overwork. Girls would be recommended to Monahan's care usually by church officials. The cost for transporting the girls was taken care of by Monahan. (Courtesy of the Akin Free Library.)

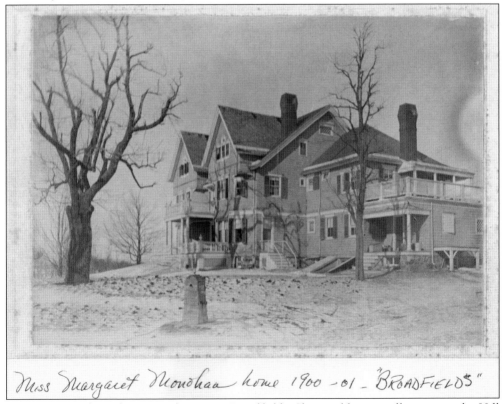

Miss Margaret Monahan home 1900 -01 "BROADFIELDS"

Margaret Monahan's home was known as Broadfields. She would eventually move to the Hill Hope House permanently after the death of her mother and father. The Monahan family was always concerned with helping others, and their generosity was unmatched. (Courtesy of the Akin Free Library.)

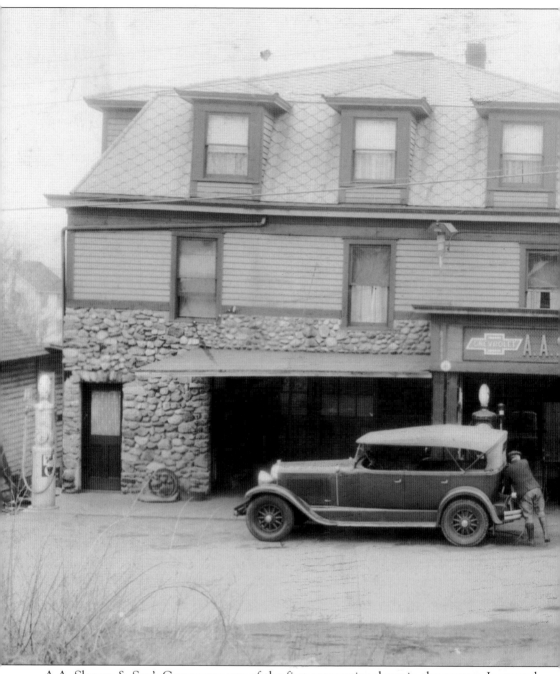

A.A. Slocum & Son's Garage was one of the first automotive shops in the county. It opened in 1914 and was operated by Alexander Slocum and his family. While his two boys, E. Munn and Allen, were off fighting in World War I, he placed his daughter Birdella in charge of office

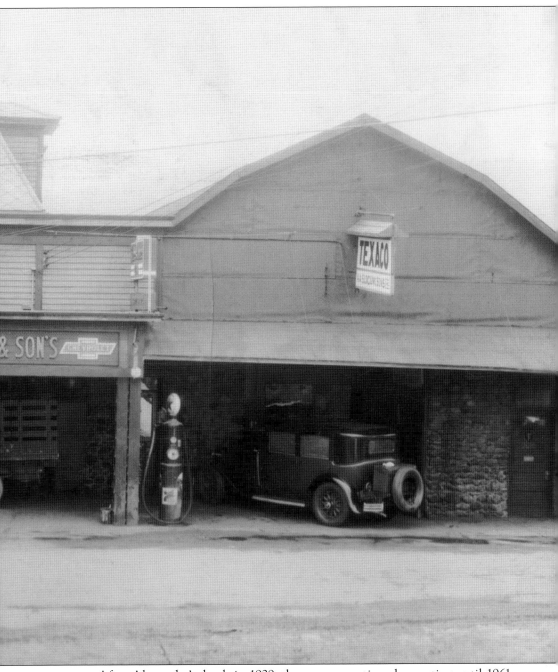

management. After Alexander's death in 1929, the garage continued operating until 1961. (Courtesy of Steve Walsh.)

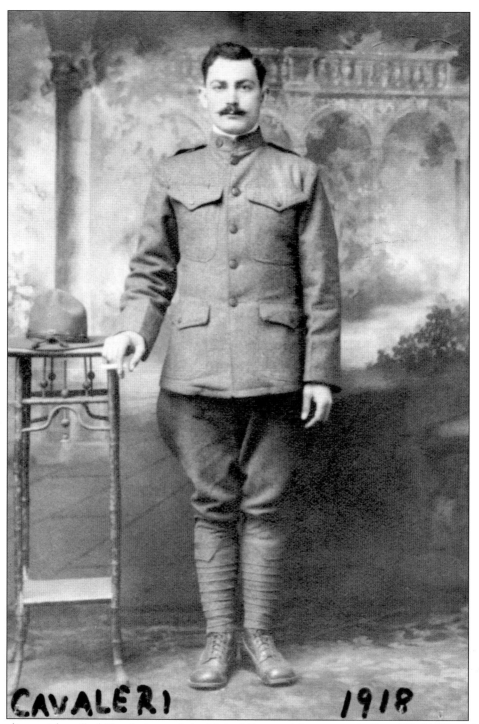

CAVALERI 1918

Pawling resident Paul Cavaleri served the United States of America proudly in World War I. In October 1891, he was born in Licata, Italy, to Vincent and Marie DeMaggio Cavaleri. Upon his return to the United States after World War I, Cavaleri married Catherine Santa Maria in 1918 and had two children with her. (Courtesy of Ed Mahaffey.)

Paul Cavaleri is seen here marching in the Memorial Day parade. He would pass away in 1982 at the age of 90. He is buried in St. John's Cemetery in Pawling. (Courtesy of Ed Mahaffey.)

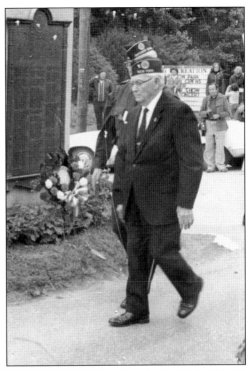

This snapshot was taken of a World War I Memorial Day celebration in the village of Pawling, on Railroad Avenue. Pawling has always aided the country when in a time of war. Whether it be by protecting George Washington during the Revolutionary War or rehabilitating injured soldiers during World War II at the Pawling School for Boys, the patriotism of the town has always distinguished itself. (Courtesy of Mike Clark.)

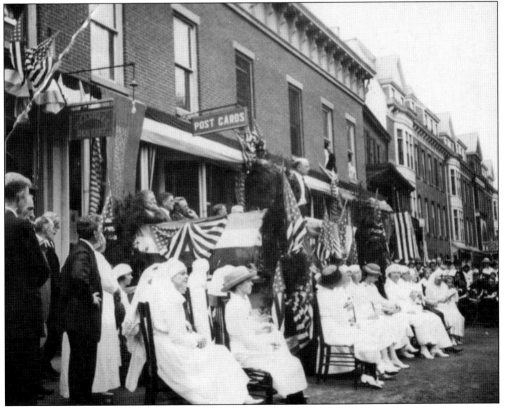

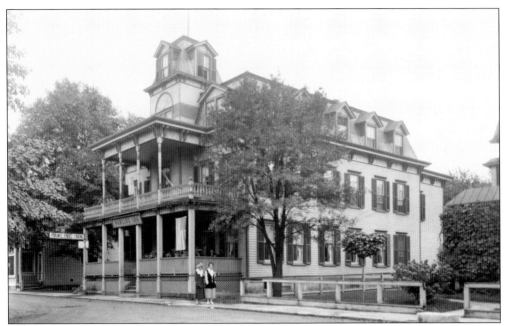

The Pawling Inn was first known as the Lee House. It was built in 1890 and burned down in February 1962. Constructed by George F. Lee on the site of his bottling works, its convenient location across from the Pawling Station provided the travelers from New York City a reprieve. It stood on the corner of Railroad Street (now Charles Colman Boulevard) and Union Street. This photograph was taken around 1920. The US flag hanging on the porch is seen with 48 stars, so it would have to have been taken after Arizona joined the United States in 1912. (Courtesy of the Akin Free Library.)

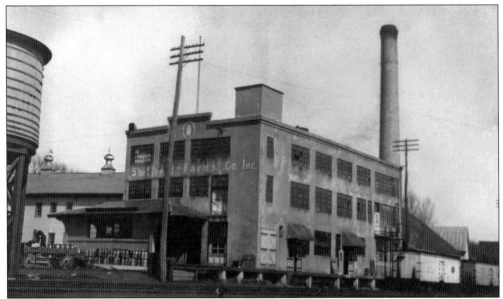

This is a postcard of Sheffield Milk Farm Company, which dissolved in 1945. Then, the building was repurposed into the Lumelite Rubber Company. The rubber company was started by Smith Johnson, Raymond Thornburg, and Howard Smith. (Courtesy of the Akin Free Library.)

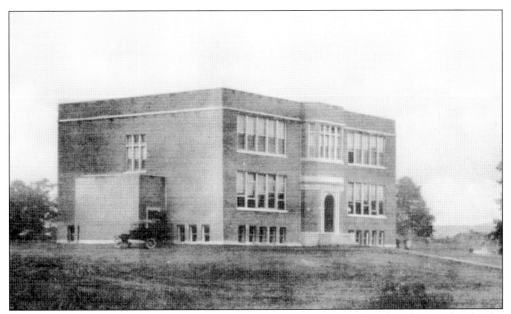

Once this building was the Pawling High School; now it serves as the elementary school. The second high school, pictured here, replaced the Taber School, which had become too small to serve the growing town. (Courtesy of the Historical Society of Quaker Hill and Pawling.)

The Slocum house on East Main Street was taken down but stood where the entrance to the Mizzentop Day School opens onto East Main Street. (Courtesy of Steve Walsh.)

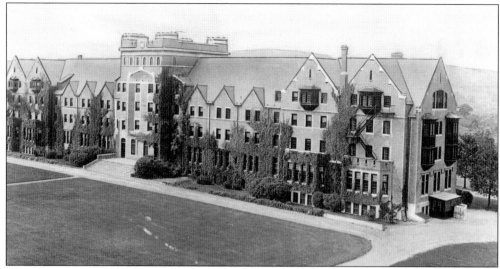

After this the Pauling School was used as a convalescent center for the US Air Force, it was purchased by the Trinity School of New York City and renamed Trinity-Pawling. It reopened in the fall of 1947. Headmaster Matthew Dann was put in charge of the boarding school, and it has been in operation ever since, attracting thousands of young men from all over the world. (Courtesy of the Akin Free Library.)

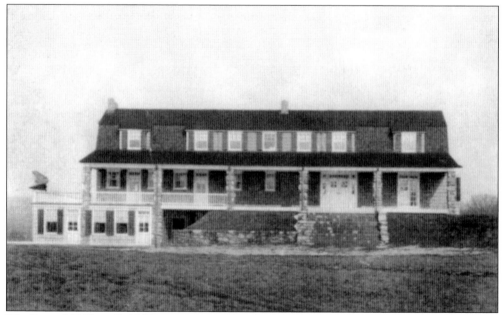

The Samuel T. Shaw Field House is now a part of Trinity-Pawling's buildings and grounds. It was originally built for the Pawling School for Boys by S. Shaw in 1913. Shaw had two boys enrolled at the school at the time of its construction. He would later say during the dedication speech that he was motivated to build it after viewing a football game from the porch of the Hotchkiss Track House. (Courtesy of the Historical Society of Quaker Hill and Pawling.)

This rare photograph of the Mizzen-Top Hotel clearly depicts its dominance over the surrounding area. For many years, the building was one of the most impressive pieces of architecture in the county. After it was torn down, the field stood vacant until the Akin Hall was moved there. (Courtesy of Don Utter.)

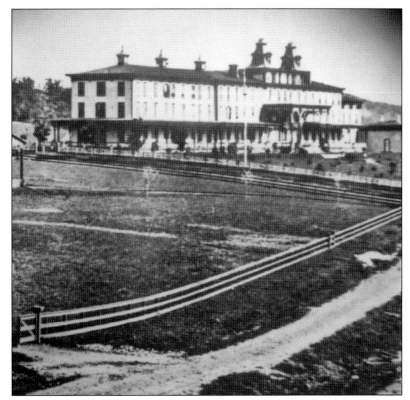

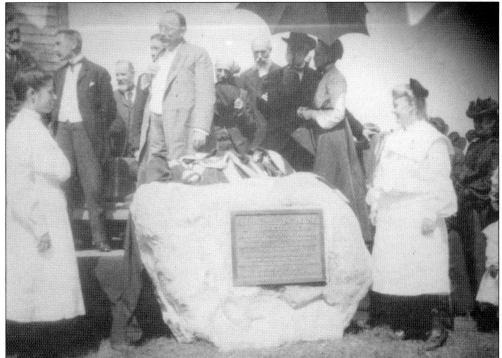

Pictured above is the dedication ceremony at the Oblong Meetinghouse. (Courtesy of Don Utter.)

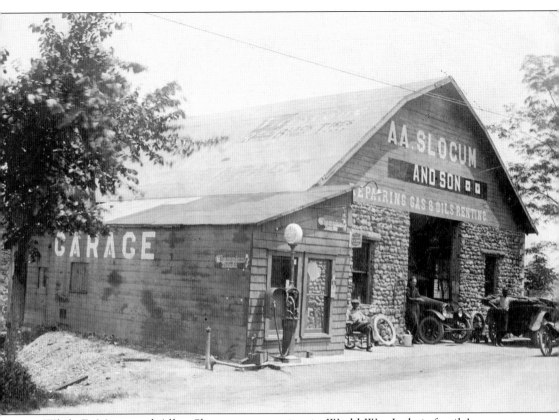

While E. Munn and Allen Slocum were serving in World War I, their family's garage was emblazoned with two active service stars on its facade. The Slocums have many heroes in their family, such as John Slocum in the Civil War; Allen, E. Munn, Howard, and Ira G. in World War I; and Louis, Oliver, and Robert in World War II. (Courtesy of Steve Walsh.)

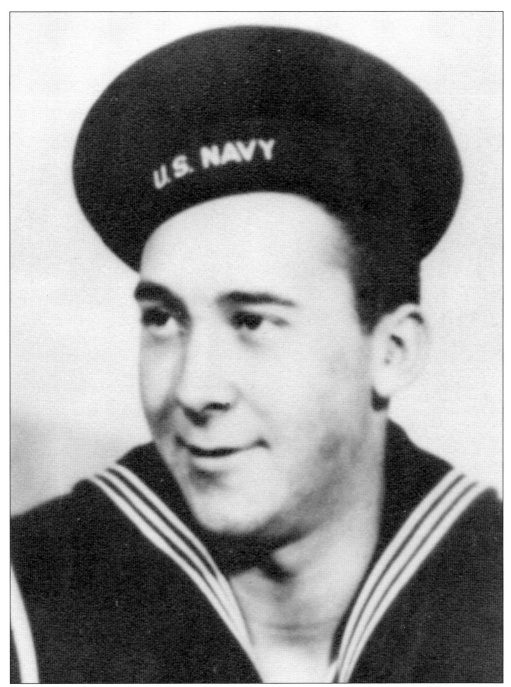

During World War II, Pawling had a population of 1,446 (in 1940). While serving their country, 13 young men of Pawling died. Pictured here is the first of the 13 to perish, John Halladay. His life was taken after his ship was hit with a torpedo in 1942. To memorialize the fallen soldiers, 13 trees were planted on what became known as Memorial Avenue. (Courtesy of the Historical Society of Quaker Hill and Pawling.)

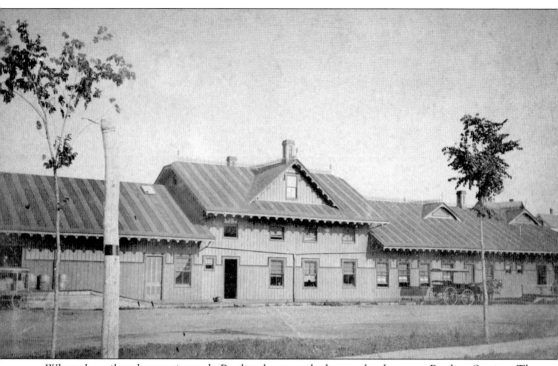

When the railroad was at its peak, Pawling began to be known by the name Pawling Station. The actual Pawling Station, seen here, was built by Albert Akin. It was constructed in the 1860s. It stood adjacent to the train tracks until it was destroyed by a fire on the morning of November 30, 1984. (Courtesy of the Historical Society of Quaker Hill and Pawling.)

Three

A SMALL TOWN ON THE ROAD TO THE WHITE HOUSE

Even though he was born in Owosso, Michigan, it will be Pawling that is forever remembered as his home. Gov. Thomas Dewey and his family lived on Quaker Hill after being shown around the town by none other than Lowell Thomas. Dewey would eventually fall in love with the town and compete for the White House on the Republican ticket against incumbent Harry S. Truman.

Dewey had made a name for himself as the district attorney for Manhattan. It was his tough-on-crime stance that won him the admiration of people all over the country. As district attorney, he pursued the world of organized crime and, ultimately, saw the incarceration of the Nazi Fritz Kuhns for embezzlement, president of the New York Stock Exchange Richard Whitney for embezzlement, and Italian mob boss Lucky Luciano for prostitution. It was in part because of his work as district attorney that he was the clear front runner for the Republican ticket in the election of 1944.

It is a shame that a two-time candidate for the presidency, a tireless crusader against crime, is today remembered as a name on the famous "Dewey Defeats Truman" photograph. Dewey was trusted by the masses in his time, and had the country not been in the thick of World War II, it would likely have been a different story. He was considered too young to lead the country during wartime.

Even though the country did not have the chance to benefit from his presidency, Pawling certainly did. His celebrity attracted famous politicians, entertainers, and athletes. He made the name Pawling appear in the *New Yorker, Life* magazine, the *New York Times,* and countless other periodicals. Today, his unassuming mausoleum stands in the Rural Pawling Cemetery next to the local elementary school. Though it only reads "Dewey" above the door, there is so much more that could be said about the governor.

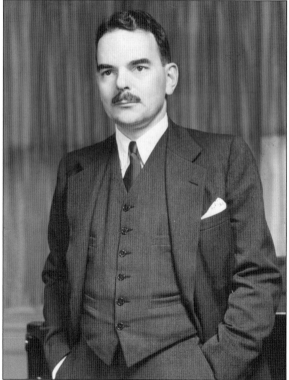

Republican presidential nominee Thomas Dewey and running mate Earl Warren are seen here in June 1948 at Dewey's home on Quaker Hill, Dapplemere Farm. Though it was his second bid for the presidency and he was projected to beat incumbent Harry Truman, Governor Dewey lost by 114 electoral votes. Earl Warren was nominated by President Eisenhower in 1953 for chief justice of the Supreme Court. (Courtesy of the Akin Free Library.)

Thomas E. Dewey is one of Pawling's most notable residents. This publicity image was captured in October 1939 while he was New York's attorney general. An enemy of the powerful New York City mafia, he made it his mission to bring them to justice. He successfully prosecuted such notable gangsters as Dutch Schultz, Waxey Gordon, and Charles "Lucky" Luciano. (Courtesy of the Akin Free Library.)

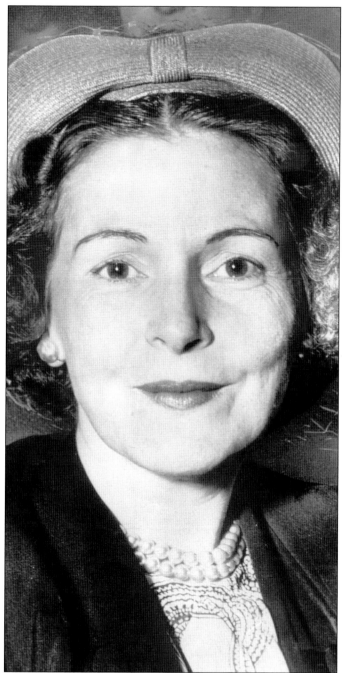

Frances Eileen Hutt was a stage actress and singer before her marriage to Thomas Dewey. She performed under the stage name Eileen Hoyt. She was the valedictorian of her high school class and won a music scholarship to the University of Oklahoma. It was a love of music that brought her and Dewey together. They met while attending music classes in Chicago during the summer of 1923. She was also the grandniece of Jefferson Davis. She passed away in July 1970, only eight months before her husband would also die. (Courtesy of the Historical Society of Quaker Hill and Pawling.)

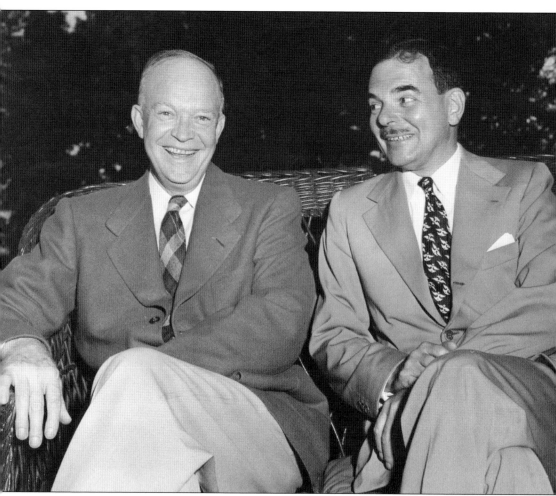

In July 1948, General Eisenhower and Governor Dewey met at Dapplemere Farm. The two Republicans supposedly met to discuss foreign affairs in Europe. It was thanks in large part to such high-profile endorsements that Dewey believed he could not lose the approaching presidential election. A false sense of security led him to pull his punches when talking about the incumbent, Harry Truman. (Courtesy of the Akin Free Library.)

Governor Dewey and family would attend church on Quaker Hill, seen here with their friend the Reverend Ralph C. Lankler. Like many of the residents of Quaker Hill, Dewey and his family were members of the Christ Church in Akin Hall. It is an interdenominational Christian church that is open to all persons of faith. After Dewey's passing, Reverend Lankler wrote a small testament to his friend Dewey. It was published by the Quaker Hill (Local History) Series. (Courtesy of the Akin Free Library.)

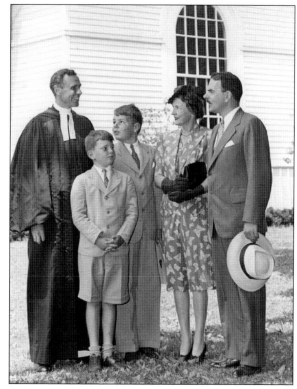

This charming interior shot is of Frances Hutt, the wife of Thomas Dewey, and their two sons, Thomas (in his mother's arms) and John. This image was captured in October 1937. They moved into Dapplemere Farm, which had been known as the Haskins House and Farm prior to their arrival. (Courtesy of the Akin Free Library.)

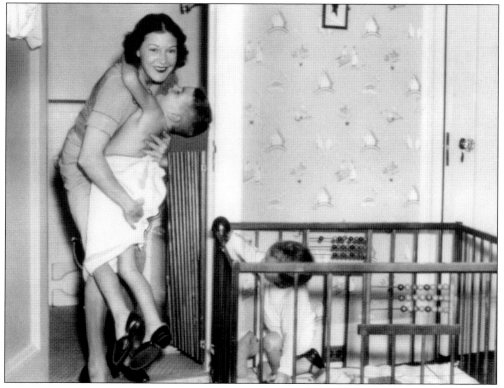

Governor Dewey is seen here playing softball. It was not a popular sport at the time, and some credit is due to Lowell Thomas for describing the rules on the radio. Governor Dewey would play his team of "Nine Old Men" against the press corps in town to report on his presidential run. His team would also play an annual game against Franklin D. Roosevelt and his team of Democrats. The results of the game were even reported in the major newspapers. (Courtesy of the Akin Free Library.)

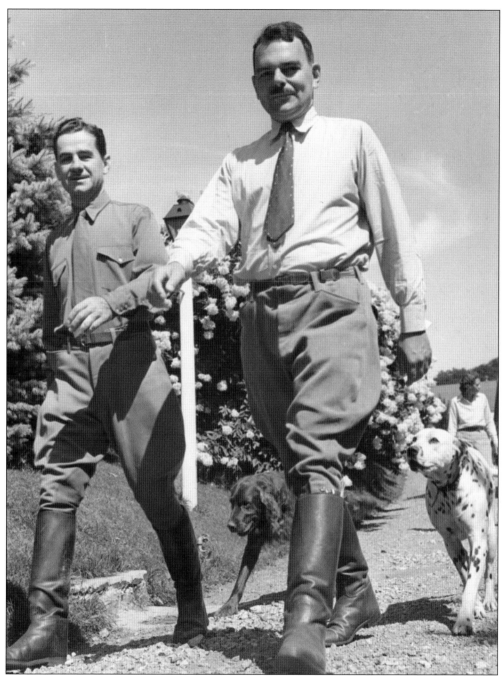

Lowell Thomas and Thomas Dewey were great friends and powerful allies. While Dewey was running for the highest office, Lowell's experience with public speaking and script writing were invaluable assets to the candidate. Dewey's youth was a problem for some people, who did not believe he had enough experience to lead the country during the volatile 1940s. To date, he is the youngest person to ever hold the Republican nomination for president at the age of 42. In the 1944 primary, he overcame the very powerful Wendell Wilkie to cinch the nomination. (Courtesy of the Akin Free Library.)

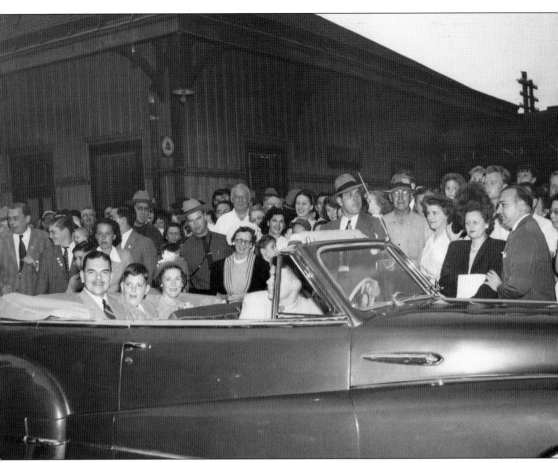

After Governor Dewey announced his campaign to run for the highest office from his home in Pawling, local townspeople rushed to the train station to apply a fresh coat of olive paint to its walls, since it was only hours until the station would be swarming with newspapermen and reporters from around the country. Eventually, the town would be so inundated with reporters that the Dutcher House would not have a room to let. The telegraph would be overworked to such an extent that it broke. (Courtesy of the Akin Free Library.)

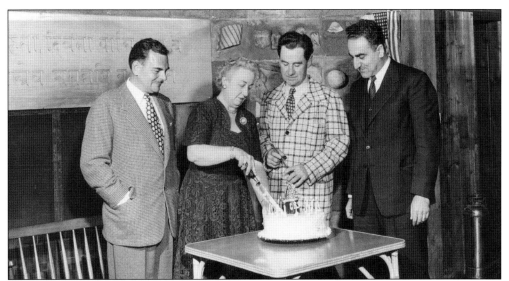

Governor Dewey entertained profusely on Quaker Hill. Standing at the far right is the Lebanese representative to the United Nation, Charles Habib Malik. A highly acclaimed diplomat, Malik was also a philosopher who is responsible for drafting the Universal Declaration of Human Rights in 1948. It was a document of such great importance that it is regarded as customary international law. (Courtesy of the Akin Free Library.)

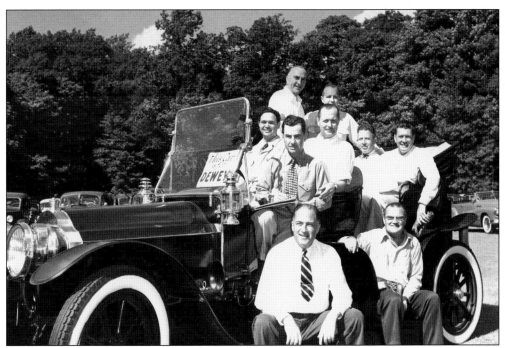

Here, Lowell Thomas, holding a clipboard, poses with other "Dewey for President" supporters known as the "Nine Old Men." Seen in this snapshot are James Melton (left of Lowell), Gen. Eddie Vernon Rickenbacker (top left), Robert Montgomery (seated directly behind Lowell with his hand on Lowell's elbow), President Eisenhower's future secretary of defense Neil McElroy (bottom left), and boxer Gene Tunney (in the far back of the car). (Courtesy of the Akin Free Library.)

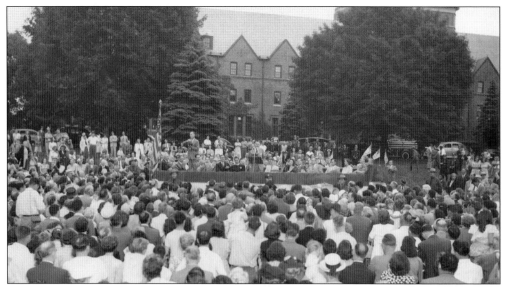

Governor Dewey on the campaign trail speaks in front of Trinity-Pawling. Due to having a town resident as a candidate for the White House, Pawling has historically leaned toward the Republican side of national politics. Governor Dewey had the misfortune of running against FDR at the conclusion of World War II. The public preferred the incumbent president. Dewey would finish the election carrying only 12 states, which earned him 99 electoral votes. Dutchess County had likely never seen more politicking, because it was the only time in US history that Republicans and Democrats nominated two candidates living in the same county. (Courtesy of the Akin Free Library.)

The theme must have been silly hats at this party on Dapplemere Farm. Dewey would entertain many different people at his Quaker Hill farm. Thanks to his and Lowell Thomas's celebrity status, the guest list would include politicians, entertainers, actors, and especially famous golfers. Note the man behind Dewey with a bird cage around his head. (Courtesy of the Akin Free Library.)

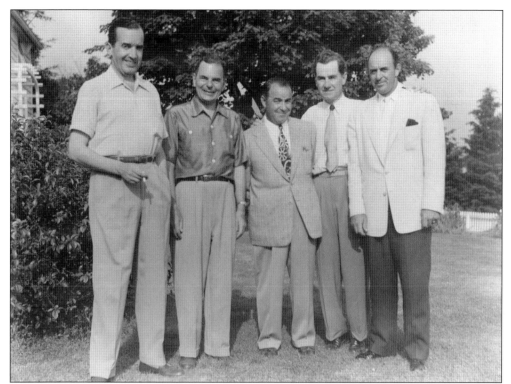

The Quaker Hill golf course was the brainchild of Lowell Thomas, who enlisted the help of Robert Trent Jones Sr. to design it. It officially opened in 1940. Pictured here are, from left to right, Edward R. Murrow, Dewey, Gene Sarazen, Lowell Thomas, and Sam Snead. (Courtesy of the Akin Free Library.)

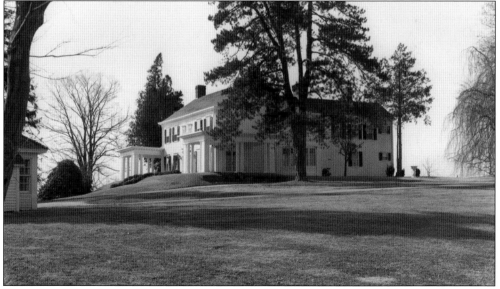

The palatial Dapplemere Farm was purchased by Thomas E. Dewey in 1939. Dapplemere was an active farm, much to the surprise of Dewey's friends. Pawling was his official residence while he ran for the office of president against incumbent FDR. (Courtesy of the Akin Free Library.)

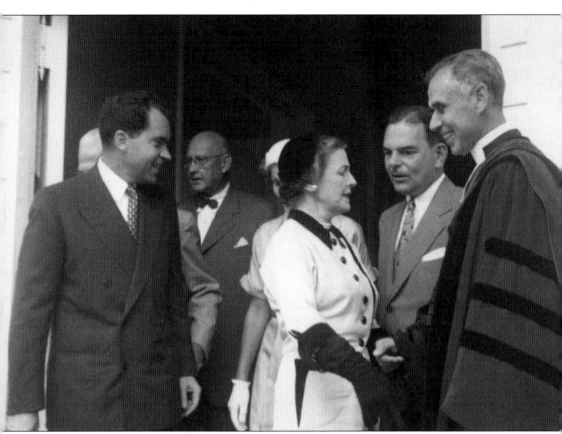

Then–vice president Richard M. Nixon attends chapel services with the Deweys at Christ Church. Quaker Hill was familiar territory to politicians thanks to Lowell Thomas's publicity campaign to promote the community among the well-to-do. Nixon in particular admired Governor Dewey for his political acumen. President Nixon would later attend the funeral for Governor Dewey in 1971 at St. James Church in New York City. Pictured are, from left to right, Vice President Nixon, Frances and Thomas Dewey, and Reverend Lankler. Pat Nixon is standing behind Frances Dewey. (Courtesy of the Akin Free Library.)

Governor Dewey loved his farm, Dapplemere. Those who would visit him in Pawling and expect to discuss politics would be surprised to hear Dewey talk for hours about his dairy farm. After retiring from political life, he was lured by Presidents Eisenhower and Nixon to accept positions in the government. It was no doubt the separation from his beloved farm that helped him to reject their offers. (Courtesy of the Akin Free Library.)

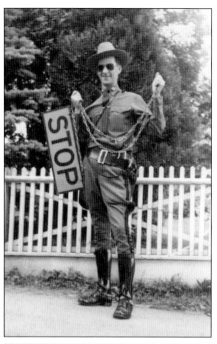

A happy state trooper poses for the camera outside Dapplemere Farm during the election of 1948. Dewey has the unfortunate distinction to be the only Republican nominated twice for the presidency and to lose both times. (Courtesy of the Akin Free Library.)

Taking a break from the campaign trail to play with his sons, Thomas Dewey Jr. and John Martin Dewey, Republican presidential nominee Thomas Dewey is photographed in July 1944. Dewey would earn 46 percent of the popular vote in the coming election. (Courtesy of the Akin Free Library.)

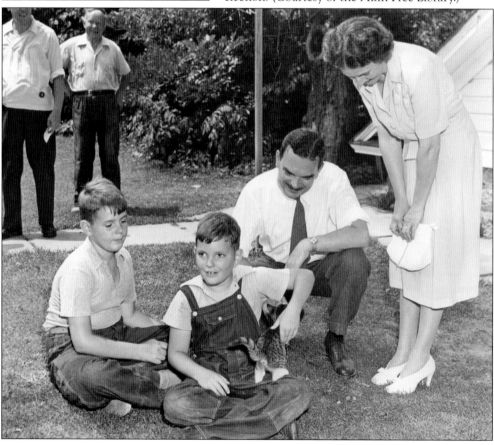

Pictured above is a postcard produced by the New York Republican State Committee to elect Thomas Dewey for president. From left to right are John Dewey, Virginia and Nina Warren, California governor Earl and Nina Warren, Frances and Gov. Thomas Dewey, Dorothy Warren, and Thomas Dewey Jr. (Courtesy of the Historical Society of Quaker Hill and Pawling.)

Dewey is seen here as happy as ever despite losing twice for the White House. His third term as New York State governor would end in 1954. Afterwards, he decided to retire from public service and focus on his law firm. When President Nixon won the White House, it was suggested that Dewey should be given a cabinet position in the administration. He was twice offered a seat on the Supreme Court but turned Presidents Eisenhower and Nixon down when they both suggested his ascension to the court. (Courtesy of the Akin Free Library.)

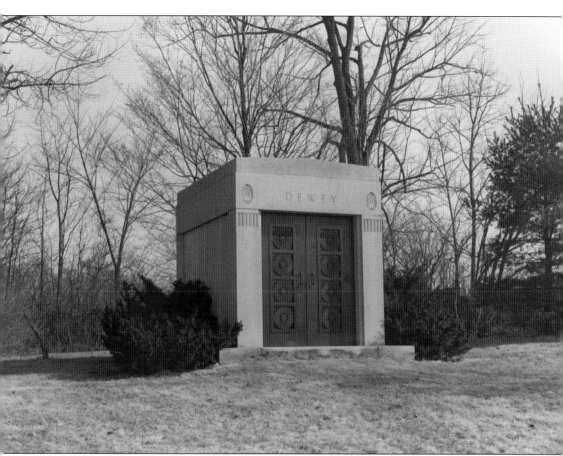

The final resting place of Governor Dewey and his wife, Frances, stands next to the Pawling Elementary School. Dewey passed away in Florida on March 15, 1971. President Nixon was expecting Dewey at the White House that night for the announcement of Tricia Nixon's engagement. After missing the appointed time for his chauffeur and phone calls from friends, he was found fully dressed and the victim of a heart attack. Frances predeceased him by only eight months. (Courtesy of the Akin Free Library.)

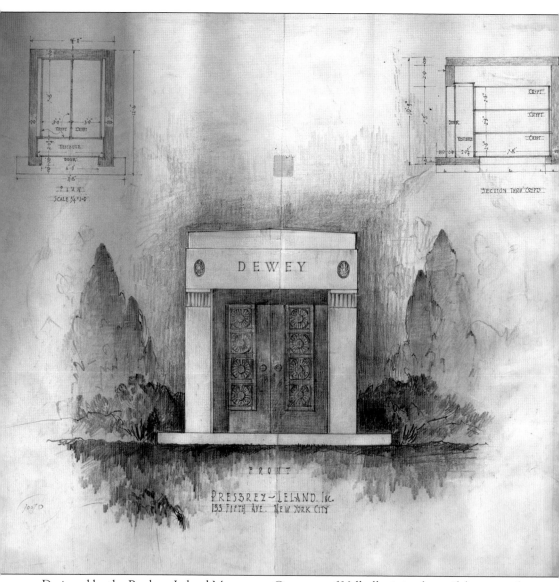

Designed by the Presbrey-Leland Monument Company of Valhalla, it is a beautiful memorial to the governor and his family. Dewey's service was held at St. James Episcopal Church in New York City and was open to the public. In attendance were President Nixon, New York governor Nelson Rockefeller, and former vice president Hubert Humphrey. (Courtesy of Earl Slocum.)

Four

THE 20TH CENTURY IN PAWLING

Only just removed from view could be what will be considered the golden age of Pawling. It was a time when Pawling was on the lips of people all over the country. Lowell Thomas, a man who it has been said "crammed a few lifetimes" into his own, would broadcast to the world from his retreat on Quaker Hill. In a humorous article by the *New Yorker*, the voters are advised against electing Gov. Thomas E. Dewey to the Oval Office because his friend and neighbor Lowell Thomas might not care for the location of the White House after relocating the Christ Church to the former site of the Mizzen-Top Hotel. To see the town and its landmarks in the Out and About section of the *New Yorker* is delightful.

Norman Vincent Peale topped the *New York Times* best-seller list with his revolutionary guide *The Power of Positive Thinking*. This work is still selling thousands of copies a year and changing the lives of people who read it. His sermons would attract the attention of millions of people listening in person or radio. In fact, when radio was at its most influential, so was Pawling.

Edward R. Murrow is arguably the most famous resident of Pawling. Only living to the age of 57, his influence in broadcasting and fair-minded news reporting may never cease to be.

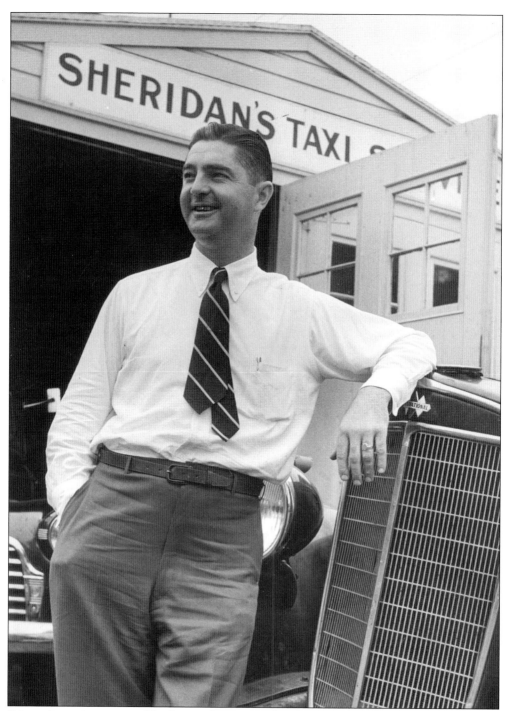

Prior to becoming mayor of Pawling in the 1940s, John Sheridan held the position of postmaster for the village post office. He was also a member of the Civil Defense Board and the Knights of Columbus. He passed away in 1976 at the age of 67. He was survived by his wife, Mary, their son, Raymond, and their daughter, Marcella. Today, the Sheridan taxi building is home to the Sunflour Bakery. (Courtesy of the Sheridan family.)

John Sheridan was mayor of the village and its 1,500 residents from 1945 to 1954. John Sheridan also operated the local taxicab company. He described himself as a lifelong Democrat but was "for Dewey first, last, and always." When he was elected mayor of Pawling, he replaced Mayor Albert H. Slocum. (Courtesy of Earl Slocum.)

From left to right are Phil, John, Redmond (Raymond), Leo, and James Sheridan. These men were invaluable to the development of Pawling, and each worked to leave the town a better place. Redmond, the patriarch of the family, was born in Ireland and was processed through Ellis Island. Not pictured is his daughter, Marcella. (Courtesy of Gregg Sheridan.)

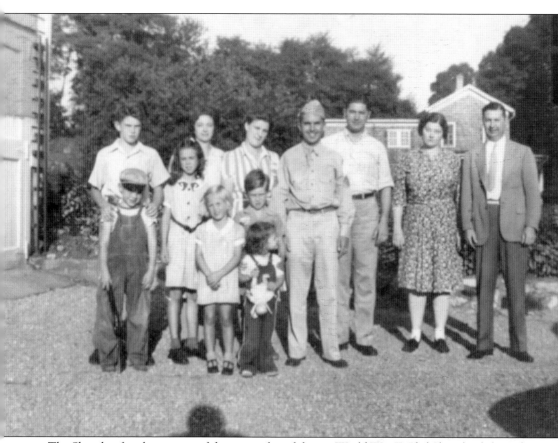

The Sheridan family sent one of their own abroad during World War II. Phil Sheridan left Pawling and sailed to Greenock, Scotland. He moved on to Northern England as a technical sergeant in Patton's 7th Armored Division. He was transferred to France, landing on Omaha Beach, where he continued east. Afterwards, he traveled to Belgium to help establish a field hospital. He was stationed in Belgium when the Germans launched their last offensive assault, the Battle of the Bulge. He would be stationed in Germany on Victory in Europe (V-E) Day and was awarded the Bronze Star while in Käthen, only 87 miles west of Berlin. This photograph was taken in June 1944 in the driveway of John's house. Pictured are, from left to right, (first row) Elaine Sheridan; (second row) Ray Sheridan and Betty, Catherine, and Tommy McGrath; (third row) Jackie and Marcella McGrath and Mary, Phil, John, Teresa, and James Sheridan. (Courtesy of Gregg Sheridan.)

The village of Pawling is a square-mile section surrounded by the town of Pawling. The village of Pawling boasts a separate government from the town. The first mayor was John B. Dutcher, who served from 1893 to 1910, an impressive feat given that elections were an annual event. (Courtesy of Earl Slocum.)

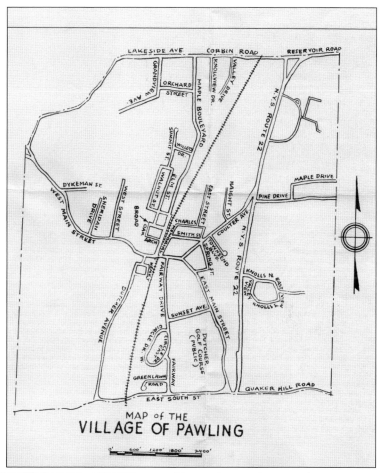

MAP of THE
VILLAGE OF PAWLING

Standing on the corner of West Main Street and Sheridan Drive, this home belonged to the Sheridan family for many decades. John Sheridan resided here while he was serving as the mayor of the village. The home was designed by the Coulter Firm, and construction began in 1926. (Courtesy of Max Weber.)

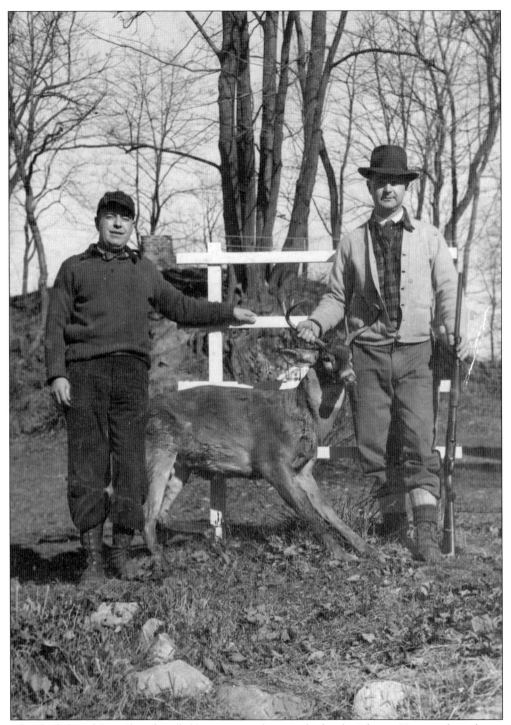

John (right) and Leo Sheridan (left) are posing here with the day's hunt. Hunting has always been a pastime for residents of the town. In addition to hunting, Leo was also an avid fisher. The town of Pawling is home to the Pawling Mountain Club, which boasts its own private reserve and is regarded as one of the most prestigious in the country. (Courtesy of the Sheridan family.)

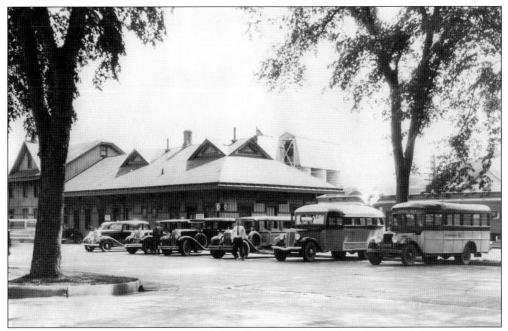

Raymond Sheridan's taxi service opened in the village of Pawling in 1907. Originally a team of horses, the business would expand into taxi cars and buses to keep up with the times. Here, Sheridan stands in front of his fleet of taxis, and in the background is the Pawling train station. (Courtesy of Earl Slocum.)

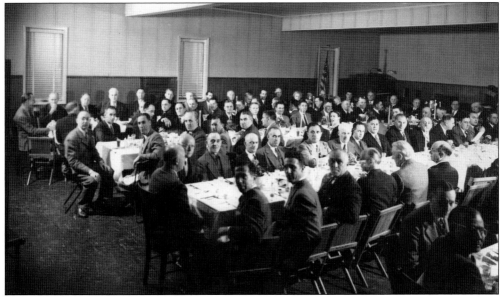

The Pawling Chamber of Commerce has changed drastically over the years. This photograph, taken in 1947, contains the most notable businessmen in the town at the time. Only two women were present in the chamber, and one of them was Mary Jones of the Starlight Theatre. Today, the chamber boasts a record number of members and works to include a more diversified committee of professionals. This was taken at Grange Hall, which is more commonly known as town hall today. (Courtesy of the Sheridan family.)

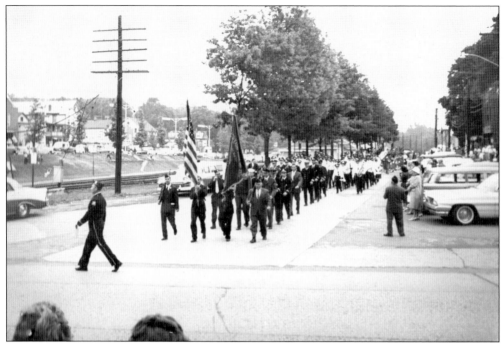

This photograph of a Memorial Day parade in the early 1960s is from the corner of East Main Street and Memorial Avenue. The name of the street prior to May 4, 1945, was Railroad Avenue. It was changed to Memorial Avenue in honor to the 13 fallen servicemen from Pawling during World War II. The Pawling Chamber of Commerce planted 13 trees as a testament to their sacrifice. (Courtesy of Ed Mahaffey.)

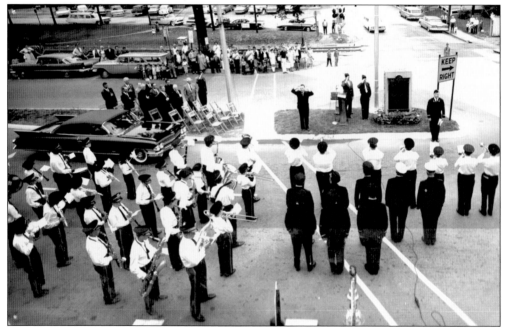

Pictured above is the Memorial Day parade through the village sometime during the 1940s. (Courtesy of Ed Mahaffey.)

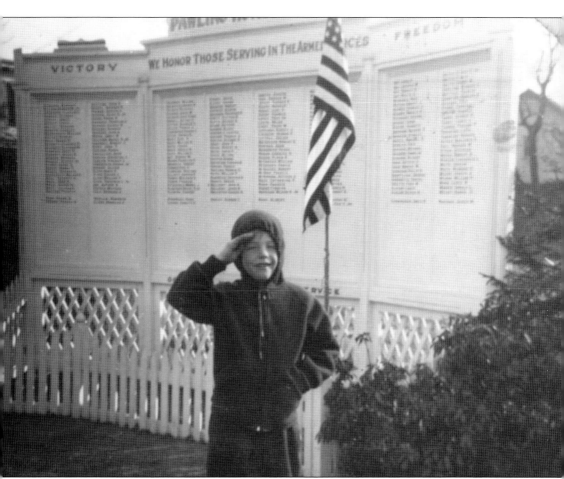

The Pawling Honor Roll stood as a reminder to the residents of the town that many men and women served their country proudly. The honor roll formerly stood in the area that is now the Key Bank parking lot. A gold star would be affixed next to the name of the service person if he or she died while fulfilling his or her duty. A young Ray Sheridan is seen here standing in front of the honor roll. Holmes also had an honor roll for its residents who served in the war. (Courtesy of the Sheridan family.)

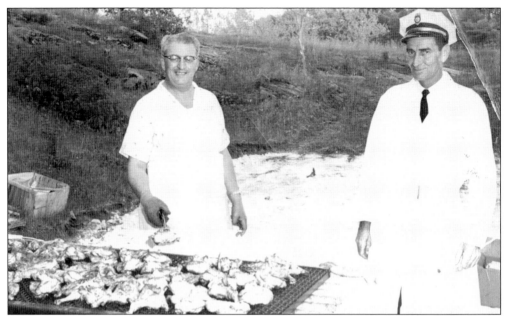

Anthony Mancuso and Tom Jones serve barbecued chicken on Route 22 in order to raise funds for the purchase of Murrow Park. Murrow Park was largely paid for with money earned by selling barbecued chicken on Sundays. It was organized by the Pawling Lions Club, which eventually built its hall at Murrow Park in 1967. The Pawling Lions Club continues to raise money for the benefit of the town and its residents. The club's motto, "We serve," does not adequately sum up all the diligence and industry it displays. (Courtesy of Nancy Clark Tanner.)

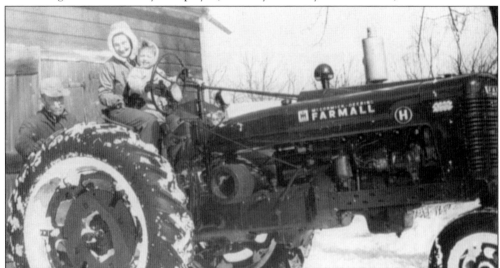

The Utter family is seen here riding its new tractor. Pictured are Chip, his wife, Marion Weeks Cobb Utter, and their daughter Marjorie. Chip Utter would pass away in 2002 at the age of 84. A lifelong Pawling resident, he served as a member of the Town of Pawling Zoning Board of Appeals for 16 years. He and his wife were members of the Pawling Grange for decades, and Marion would eventually become its president. She arrived in Pawling from Scranton, Pennsylvania, to teach art in the Pawling School District in 1941. They were married in 1943 and raised their four children on the farm. (Courtesy of Don Utter.)

The Catholic Daughters of Pawling, seen here, were one of the most popular organizations in the town. Father Storm stands left center, and Father Dwyer is the priest on the right in front of the congregation. (Courtesy of the Sheridan family.)

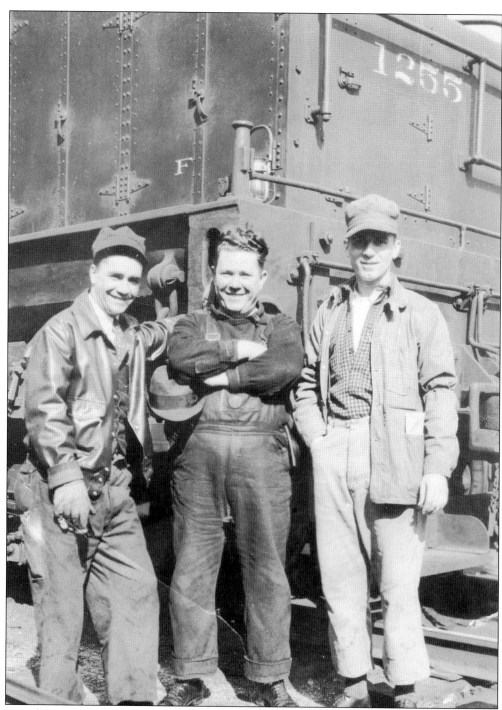

From left to right are Jim Carrello, unidentified, and Robert Palmer. The Harlem Line would transport a wide variety of goods to and from Pawling. Beginning with food and produce grown locally and sent to New York City, the farmers eventually took advantage of the Rutland Milk Train to ship milk southbound. During the Korean War, tanks were loaded onto flat train cars and shipped eastbound. (Courtesy of Nancy Clark Tanner Library.)

From left to right are Bobby Utter, Rose Marie Mina, Vera Utter, and Jess Davis in front of the Holmes Store (now Armando's Deli and Market). The store was built in 1940 by John "Vernon" Utter. This photograph was most likely taken in the late 1940s or early 1950s. (Courtesy of Mark Bailey.)

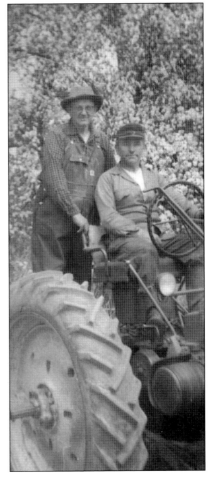

Mr. Byrd and Mr. Pentz are working on the Byrd's Hill Farm sometime during the 1960s. Apple trees are blossoming in the background. The farm stood off of Byrd's Hill Road on Quaker Hill. (Courtesy of Don Utter.)

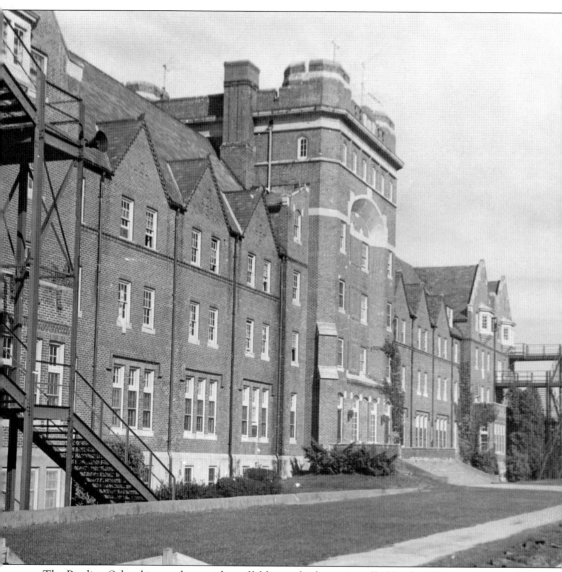

The Pawling School is seen here with scaffolding, which was installed by the US government while it was an Army rehabilitation center. The US government helped rebuild the school and bring it up to code. This would not be the last time Trinity-Pawling would require massive rebuilding. A devastating fire in February 1969 would destroy the south end of Cluett Hall. The electrical fire started on the second floor and spread upwards, causing the fourth floor to be removed during reconstruction. One fireman was lost during the fire; Nicholas Taska's life was taken while fighting the fire on the third floor of the building. (Courtesy of Trinity-Pawling School.)

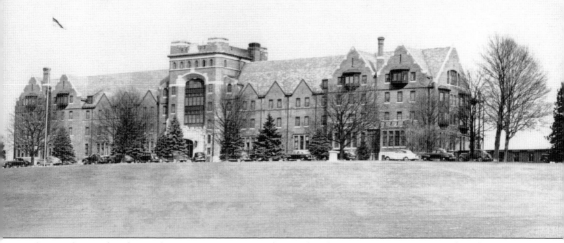

The Pawling School, now known as Trinity-Pawling School, was founded by Dr. Frederick Luther Gamage in 1907. He originally wanted to house his school at Halcyon Hall in Millbrook. After arriving too late to make an offer for the hall, he was returning to New York City when the train he was riding stopped in Pawling. He was inspired by the imposing edifice of the Dutcher House to establish a school in the area. The first student body numbered 85 boys, and the curriculum included English, Latin, Greek, French, German, mathematics, science, and history. Dr. Gamage had plenty of experience, having served as headmaster of St. Paul's School in Garden City, New York. Upon his resignation, St. Paul's faced a crisis when the entire faculty quit with Dr. Gamage. Many of the teachers would follow Dr. Gamage to Pawling and provide their expertise to the new Pawling School. (Courtesy of Trinity-Pawling School.)

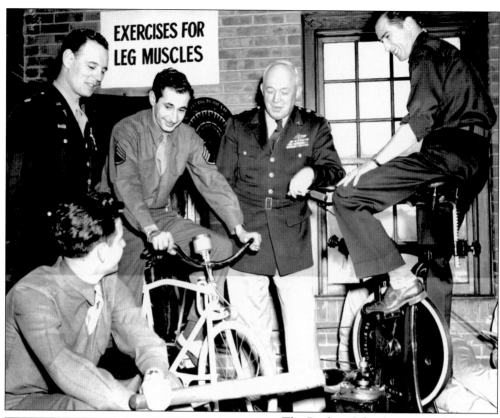

EXERCISES FOR LEG MUSCLES

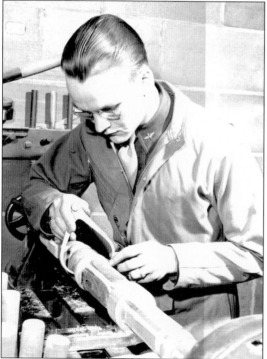

The Pawling School was turned into an experimental Army hospital and health center during World War II. Therapy machines were used as part of the new proven method for rehabilitation. From left to right are Sgt. Elwyn Murray; Lt. Col. Hobart H. Todd; Sgt. Abraham Bohn, who was shot down over Romania during a raid; Gen. Henry H. Arnold, chief of the Army Air Forces; and 1st Lt. Franklin Jape, a navigator. This photograph was taken on January 11, 1945. (Courtesy of the Historical Society of Quaker Hill and Pawling.)

Arnold W. Larson of South Dakota is at work in the woodshop of the Pawling School. This rehab center was the only one of its kind in the country. Residents were permitted to choose their preferred form of rehabilitation from a list of activities. (Courtesy of the Historical Society of Quaker Hill and Pawling.)

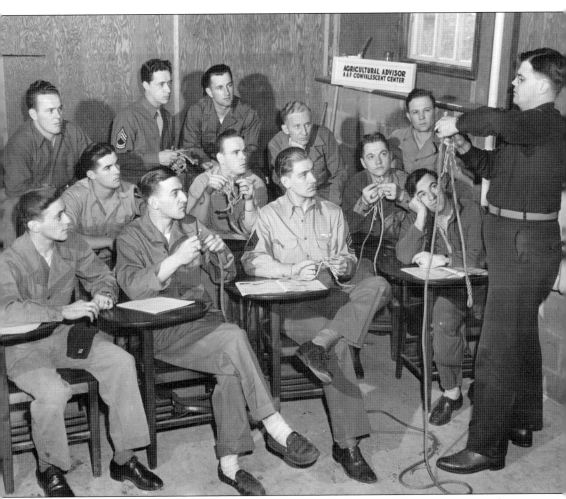

This group of soldiers is recuperating at the Pawling School Convalescent Center, which is today's Trinity-Pawling. During World War II, it could house 200 wounded soldiers with the goal of returning them to duty as soon as possible. The group here is learning how to splice broken rope. The convalescent center was the only one of its kind and was a part of Pawling's war effort. Lt. Varnum D. Ludington is seen standing. (Courtesy of the Akin Free Library.)

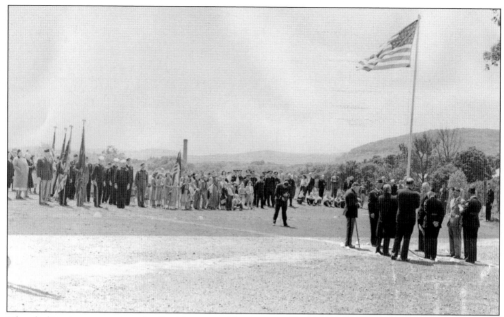

The dedication ceremony for the Veterans Cemetery of Pawling occurred on July 1 in the 1940s. The cemetery and the land it occupies belong to the American Legion Hasler-Kamp Post No. 215 of Pawling. Prior to the exchange of land, it was jointly owned by St. John's Catholic Church and the Pawling Rural Cemetery. It was exchanged to the American Legion post for a dollar and a handshake bargain. (Courtesy of Ed Mahaffey.)

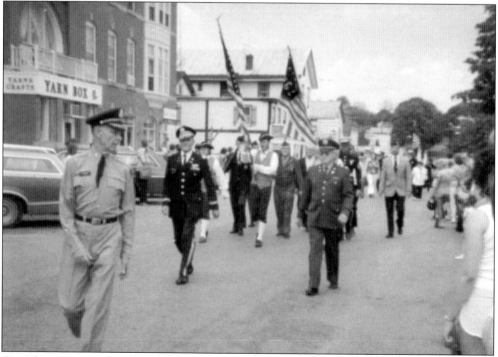

Gus Thomes is seen here leading the annual Memorial Day parade down the streets of Pawling. (Courtesy of the Sheridan family.)

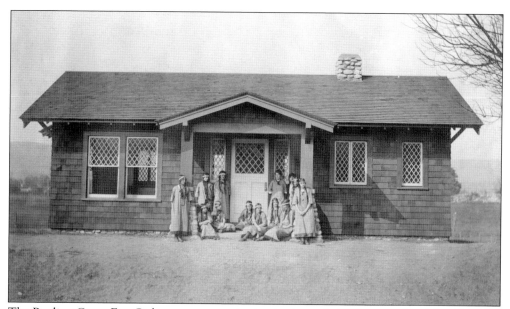

The Pawling Camp Fire Girls were an organization in the early 1900s created by Mary Taber. A precursor to the Girl Scouts, the original group consisted of Frances Brown, Altana Burr, Susan Litchfield, Grace Reynolds, Ada Slocum, and Thelma Smith. The girls raised money by holding bake sales, pageants, concerts, and theatrical productions in order to construct their cabin. (Courtesy of the Historical Society of Quaker Hill and Pawling.)

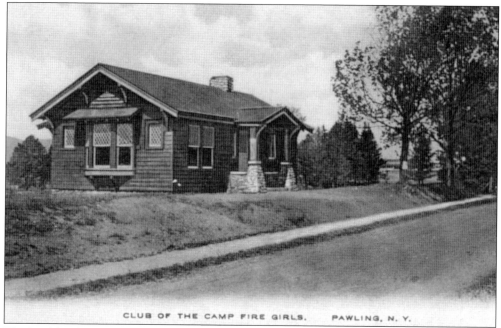

CLUB OF THE CAMP FIRE GIRLS. PAWLING, N. Y.

The land for the Camp Fire Girls was donated to them by the Taber family. It formerly stood off of Route 22. The dedication ceremony for the cabin was attended by the governor of New York State, Charles Seymour Whitman. (Courtesy of the Historical Society of Quaker Hill and Pawling.)

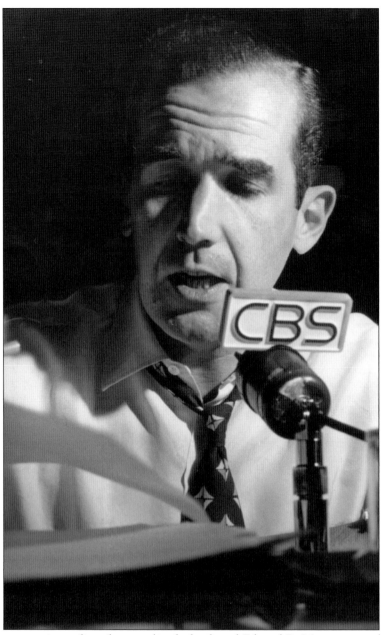

Likely the greatest journalist who ever lived, the famed Edward R. Murrow was also lured to Pawling by Lowell Thomas. Lowell gifted the use of a log cabin on Quaker Hill to Murrow, which he was free to occupy whenever he could escape New York City. Murrow was an avid golfer, and he would not settle in it until he had played the links. Murrow's impact on journalism is undeniable. It was his voice that reported on the progress of World War II. He would fly with Allied bombers and would be the first reporter in the Buchenwald concentration camp. It was his voice that brought the horrors of Nazi Germany to the ears of people all over the world. His report filed on April 15, 1945, three days after the Allies freed Buchenwald, consists of one page of short disjointed paragraphs. Towards the end, he wrote, "For most of it, I have no words." (Courtesy of the Historical Society of Quaker Hill and Pawling.)

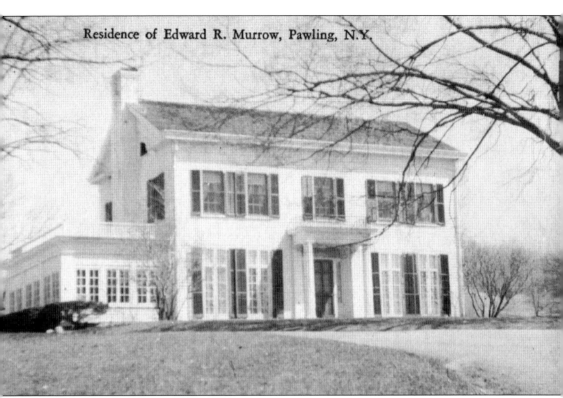

Residence of Edward R. Murrow, Pawling, N.Y.

Edward R. Murrow loved the tranquility of Pawling. He would eventually move into Glen Arden Farm on Quaker Hill. It was obviously his favorite place to be, as it was where he requested his ashes spread. Edward R. Murrow would pass away at his home on April 27, 1965, the result of his infamous three-packs-of-Camels-a-day smoking habit. He lived for two years after undergoing surgery to remove the lung cancer that would eventually claim his life. (Courtesy of the Historical Society of Quaker Hill and Pawling.)

Golf has always been a favorite sport in Pawling. The village is home to the oldest public golf course in the United States. It was commissioned by John Dutcher after he had taken a trip to Scotland. It opened in 1885 and was used primarily by the residents of his hotel in the village. Lowell Thomas is seen here with a golfing party. (Courtesy of the Akin Free Library.)

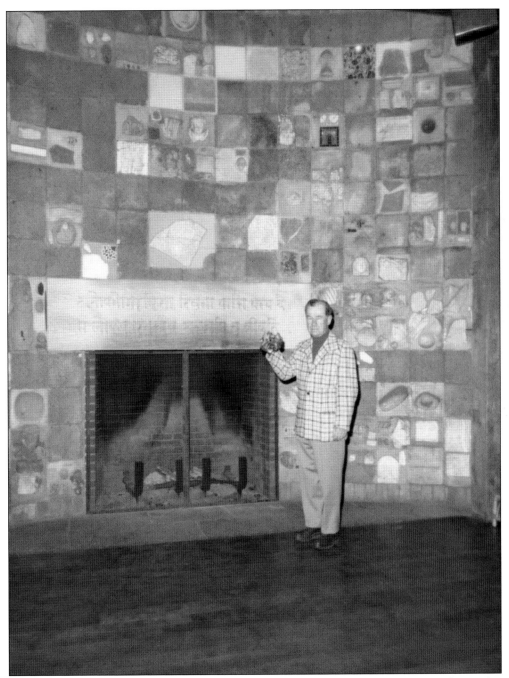

Lowell Thomas is seen here standing in front of the History of Civilization Fireplace. This amazing collection is located at the Quaker Hill Country Club, which was founded by Lowell Thomas. Each block holds an artifact that is representative of a notable moment in the history of humanity. Many of the artifacts could only be collected by someone with Lowell's credentials. Pieces of the Great Pyramids of Giza, Taj Mahal, Great Wall of China, Golden Gate Bridge, and Empire State Building are just some of the amazing artifacts in the wall. The Quaker Hill Country Club opened on May 30, 1941. (Courtesy of the Akin Free Library.)

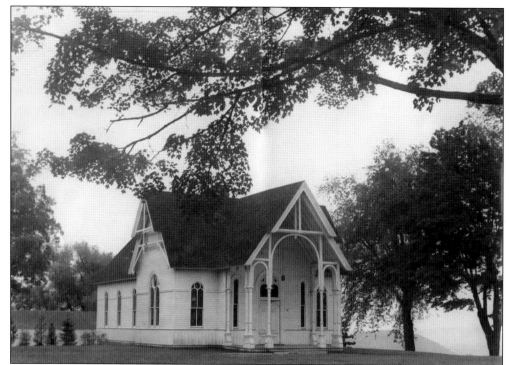

Built as the headquarters of the Akin Association, this building was designed by the architect J.A. Wood of New York City. The Victorian style of the structure was the original design. Today, it is more commonly known as Christ Church. As a place of worship, it is nondenominational. It is no longer in the Victorian style and sports a spire upon its roof. The spire was added by Lowell Thomas after the building had been renovated to serve as a place of worship. (Courtesy of the Akin Free Library.)

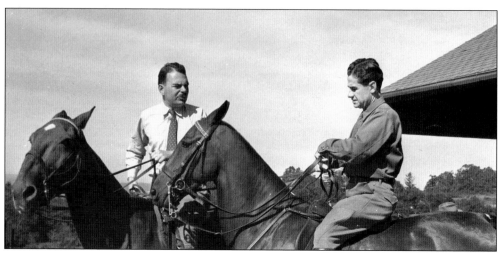

Pictured above are Dewey and Lowell on horseback on Quaker Hill. (Courtesy of the Akin Free Library.)

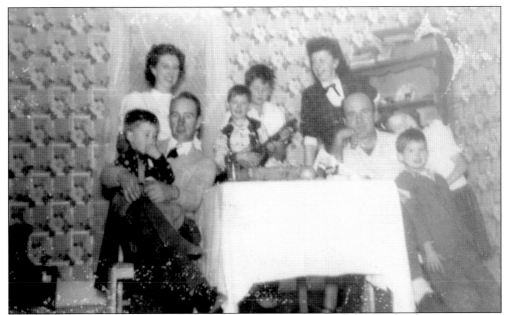

The Dewitts and the Mahaffeys were both merchants in the village of Pawling. They were also neighbors on Railroad Avenue. Sunday dinner was always shared together. This c. 1950 photograph was taken at the Dewitts' home. From left to right are Sam Mahaffey with young Ed on his lap; Gert Dewitt; George Mahaffey; Floyd Dewitt; Velma Mahaffey; Mead Dewitt; Mary Lou Dewitt; and Bob Dewitt. (Courtesy of Ed Mahaffey.)

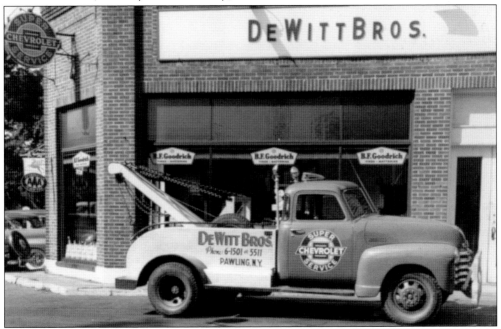

Dewitt's Garage and Showroom stood on the corner of Railroad Avenue and Broad Street, the current site of Pawling Karate. In addition to repairing cars, it also offered new car sales. It even boasted an in indoor showroom. Bothers Floyd and Bob Dewitt ran the business. (Courtesy of the Sheridan family.)

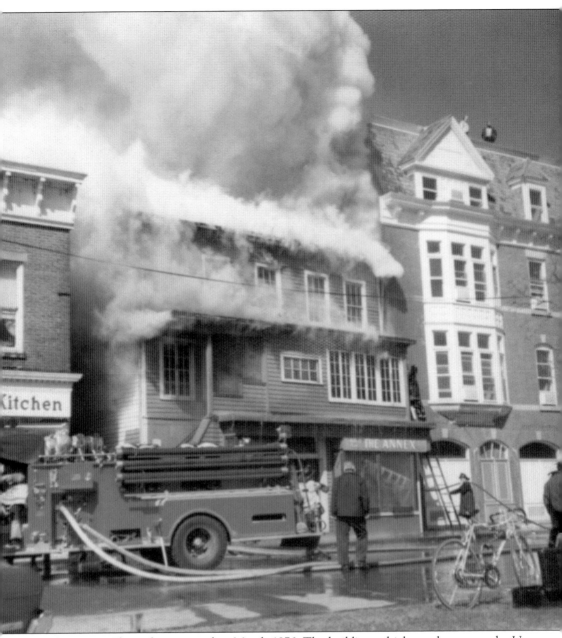

The Annex Florist fire occurred in March 1976. The building, which was known as the Utter Building, was ablaze on the second floor. Ed and Mary Mahaffey used the bottom right storefront as their florist shop. The left side of the building housed Lynne and Kevin Denton's antique store. The fire occurred just two weeks before Easter, when both stores were full of inventory to be sold. Anyone who was around when the fire broke out jumped at the chance to help their friends and neighbors rescue the merchandise. After the fire was extinguished, the Annex Florist reopened temporarily in Vinnie Moreno's pharmacy, the Prescription Shoppe, which is now Good Tidings. After the Easter holiday, they florist would reopen for one year on Broad Street. (Courtesy of Ed Mahaffey.)

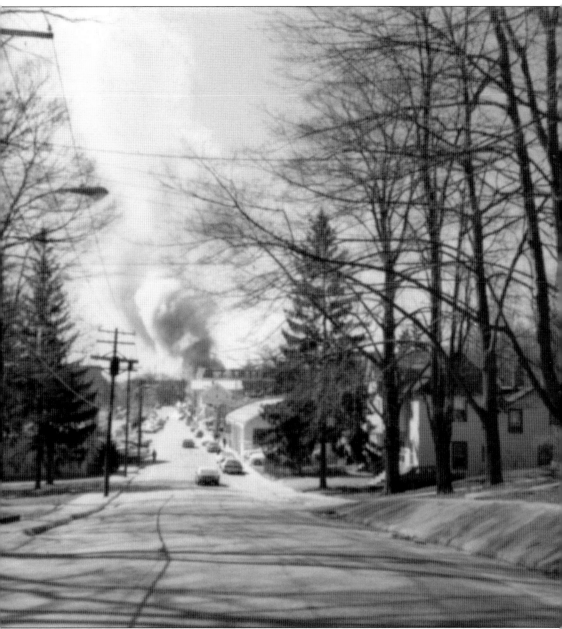

Ed and Mary Mahaffey would bring their cut flowers from their greenhouses to their storefront every day. The three Mahaffey greenhouses on Charles Colman Boulevard were purchased from Albert Slocum by Sam and Velma Mahaffey of Sherbrooke, Quebec, around 1947. The first Annex Florist shop opened in 1969. It moved to its current location in the Dutcher House in 1977. Both of these photographs of the Annex fire, as it has come to be known, were taken by Ned Reade. (Courtesy of Ed Mahaffey.)

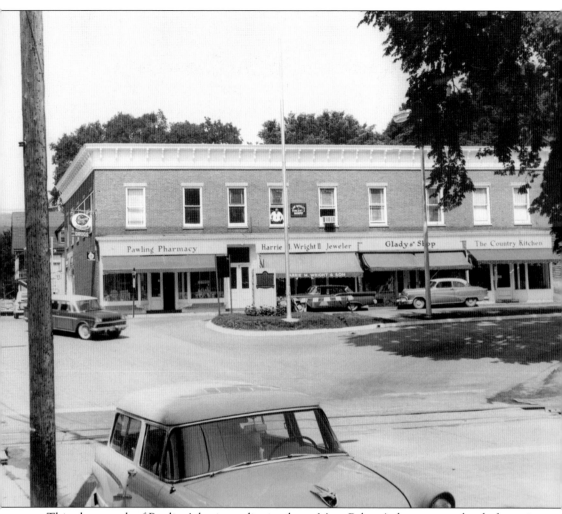

This photograph of Pawling's business district shows Mary Palmer's drugstore and soda fountain on the corner of Maple Boulevard and West Main Street. Harrie Wright II's jewelry store was the place to go if one needed to repair a piece of heirloom jewelry or were looking to purchase a high-quality bracelet, ring, or necklace. He even sold Nativity sets around the holidays. Harrie Wright's father, of the same name, was an invaluable member of the village. For a number of years, he was the only optometrist around. He was also the postmaster of the town. Once, when the post office was ablaze, it is reported that he and a small number of volunteers rescued every piece of mail down to the last postcard before the blaze consumed the building. Gladys's dress shop was located on the second floor of the building and sold ladies' and children's apparel. The men would need to walk up Maple Boulevard to Chertock's Department Store, located on the corner of Maple Boulevard and Arch Street, to buy their clothes. (Courtesy of the Historical Society of Quaker Hill and Pawling.)

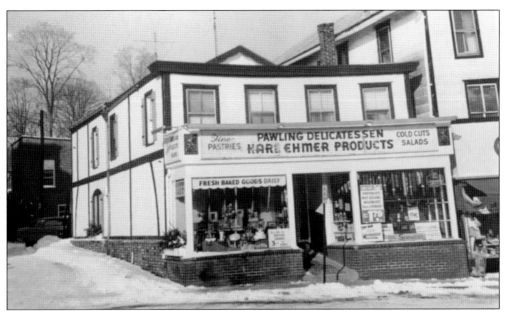

This beloved delicatessen was founded in 1932. The Pawling location was managed by Erika Lidl. Karl Ehmer opened his first location in New York City on Forty-Sixth Street and Second Avenue. Karl Ehmer's can still be found, although in the Internet age, its products can be ordered online. Its traditional German food was highly regarded in the town for years. The building was compromised when its neighbor, Chertock's Department Store, caught fire and fell down. (Courtesy of the Sheridan family.)

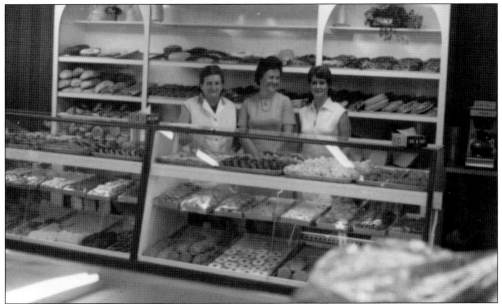

Seen here behind the bakery counter of Karl Ehmer's of Pawling are, from left to right, Anna Ehmer, Erika Lidl, and Anita Griffin. Erika Lidl opened the German delicatessen in 1971. She would remain the manager until she sold the business in 1976. The people of Pawling still miss her famous roast beef made on site. The *konditors* (not bakers) would sell cakes and pastries to the town residents whenever they had a special occasion. (Courtesy of Erika Lidl.)

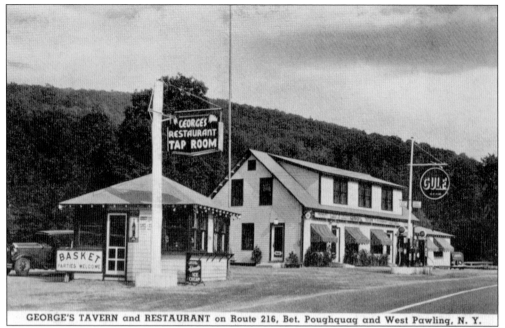

GEORGE'S TAVERN and RESTAURANT on Route 216, Bet. Poughquag and West Pawling, N. Y.

George's Taproom was located in the hamlet of West Pawling. West Pawling is not known as a hamlet today. George's Taproom was open in the first half of the 1900s. It would become Hunt's Bar in the 1940s and is remembered today for attracting a rougher type of customer. (Courtesy of Mark Bailey.)

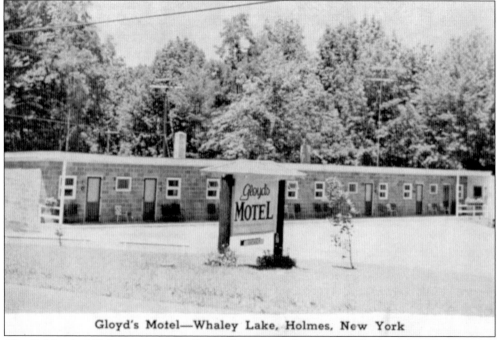

Gloyd's Motel—Whaley Lake, Holmes, New York

Gloyd's Motel of Holmes was open all year for visitors. Sitting on Whaley Lake off Route 216, it afforded guests lake privileges. It was operated by Harold and Dorothy Gloyd. (Courtesy of Mark Bailey.)

Whaley Lake is the largest natural lake in Dutchess County. After incalculable centuries serving the needs of Native Americans, it became an oasis for trappers and mountain men of the area. The resources provided by the lake lured settlers to establish communities within the boundaries of what would become Pawling. (Courtesy of the Sheridan family.)

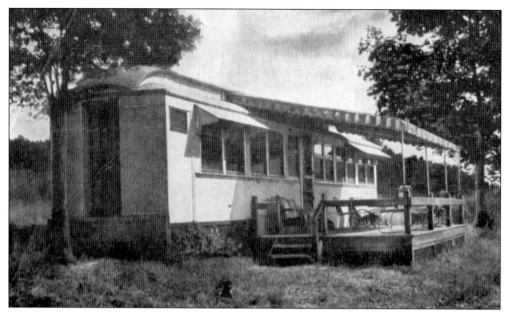

This postcard of a Pullmanette car is from the Sanita Hills Camp, which operated in Holmes. The repurposed train cars would be used for summer housing while their inhabitants relaxed and took in the surrounding area. There were 32 decommissioned train cars at the peak of the camp's administration. Each Pullmanette was equipped with a bedroom, kitchen, and bathroom. After the camp closed down, the land was given to the local Boy Scouts. Only one dilapidated Pullmanette car is said to survive somewhere in the woods of Holmes. (Courtesy of Mark Bailey.)

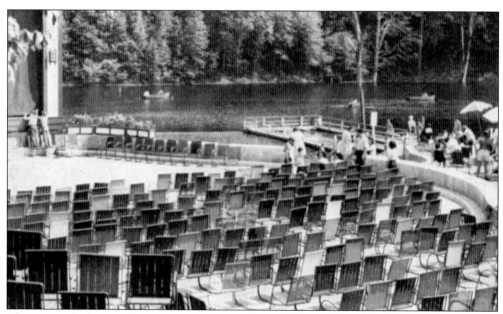

This postcard advertises the amusement area at Sanita Hills in Holmes. Sanita Hills was operated for the New York City sanitation workers (hence the name). The camp was only used during the summer months for sanitation workers and their families. The camp was closed down in the 1970s. Today, the area is known as Little Whaley Lake. (Courtesy of Mark Bailey.)

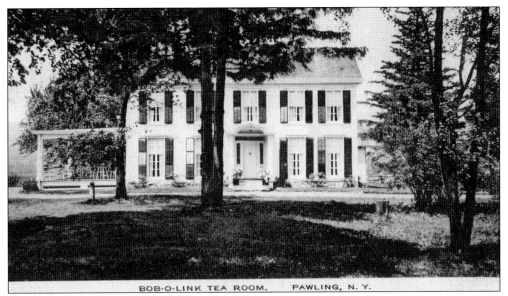

BOB-O-LINK TEA ROOM. PAWLING, N. Y.

The Bob-o-Link tearoom was operated by Mr. and Mrs. C. Bradley Sanders. Situated next to the Dutcher Golf Course on East Main Street, it was a convenient place for golfers to stop for lunch. The interior walls of the house were decorated with delicate hand-painted bobolink birds. (Courtesy of the Akin Free Library.)

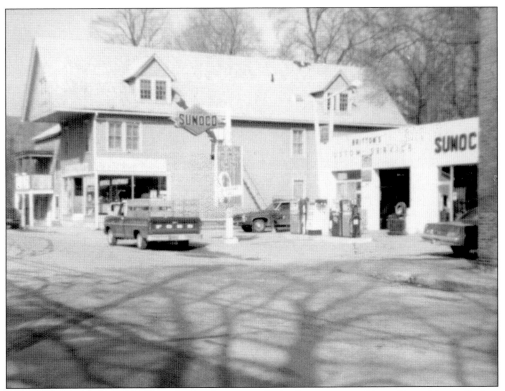

Today, the Family Quick Stop is the local watering hole that many could not live without. Before it was opened, it was known Britton's Garage. (Courtesy of Nancy Clark Tanner.)

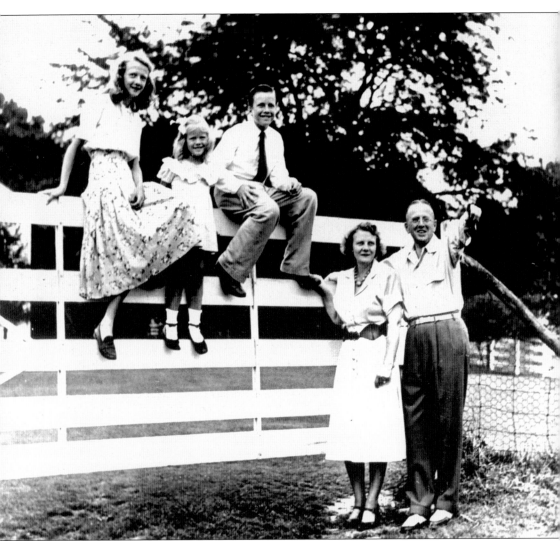

Rev. Dr. Norman Vincent Peale and his family are seen here at their home on Quaker Hill. Ruth Stafford met her future husband, Peale, in Syracuse, New York, where she was a teacher of mathematics; they married in 1930. Of her many accomplishments in life, she has the distinction to be the first female president of the National Board of Ministers in North America. She was the recipient of the Horatio Alger Award for Distinguished Americans and was the choice for the American Association of University Women "Woman of the Year" Award in 2000. From left to right are Margaret, Elizabeth, John, Ruth, and Norman. (Courtesy of the Peale History Center and Library.)

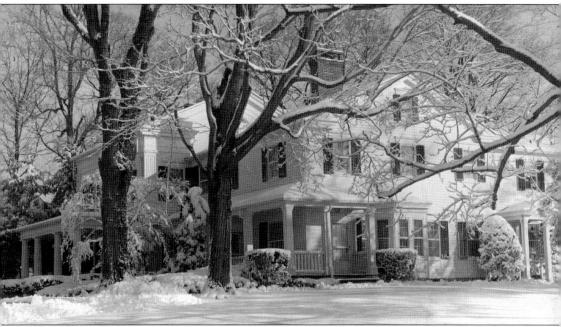

Though Norman Vincent Peale's life ended in 1993, his hard work and philosophy are still having positive effects today. His magazine *Guideposts*, which commenced publication in 1945, is still being published 10 times a year in both print and digital formats. After his passing, Ruth Stafford Peale went on to serve as the chair of the board of *Guideposts* until 2003. She lived to be 101 years old and passed away in Pawling in 2008. (Courtesy of the Peale History Center and Library.)

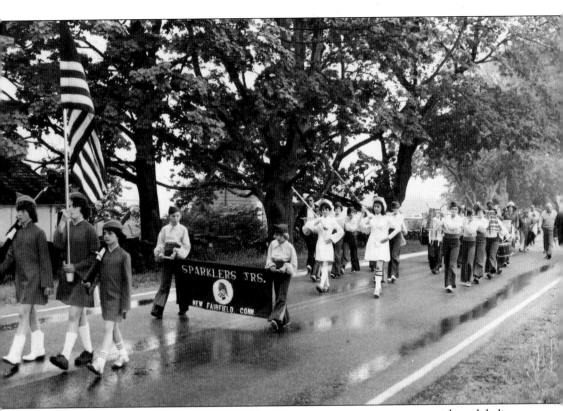

The Sparklers Jrs. came from New Fairfield, Connecticut, to participate in parade and dedicaton festivities for the Mizzentop Firehouse. The firehouse was located only a few hundred yards from the Fairfield County line. (Courtesy of the Peale History Center and Library.)

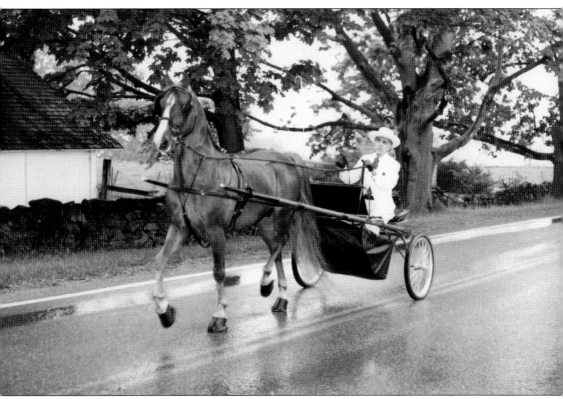

John K. Schemmer is seen here in one of his chariots on his way to the Mizzentop Firehouse dedication ceremony. He was a successful lawyer who divided his time between Pawling and New York City. He loved horses and was a resident of Quaker Hill, a very common concurrence. (Courtesy of the Peale History Center and Library.)

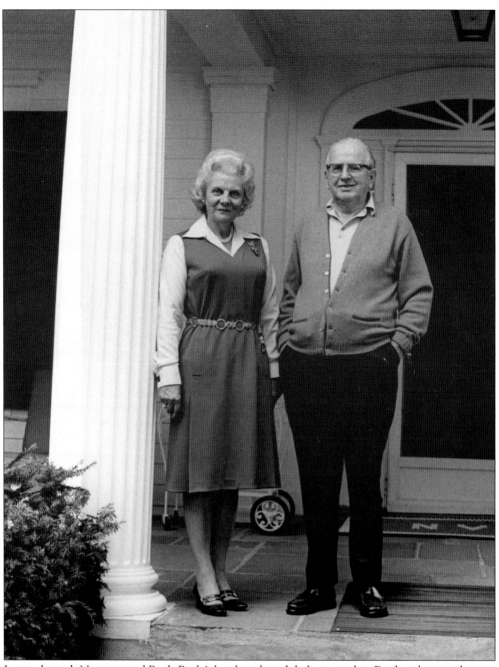

It was through Norman and Ruth Peale's hard work and dedication that Pawling became known as the "Home of Positive Thinking." His Peale Center opened its doors in 1940 in New York City and moved to Pawling in 1952. The Peale Center would receive upwards of 2,000 letters a week from people asking for guidance and prayer. Though both were published authors, it was his 1952 *New York Times* bestselling book *The Power of Positive Thinking* that launched the pair into the public's eye. It would remain on the *New York Times* list for 186 weeks (48 in the No. 1 nonfiction spot.) The Peale Center was also a nondenominational Christian school that trained ministers. (Courtesy of the Peale History Center and Library.)

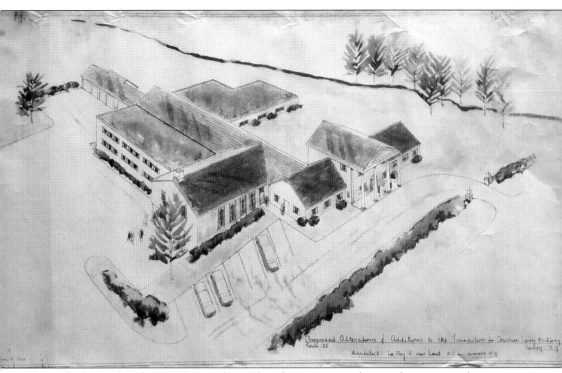

The Peale Center for Christian Living (PCCL) underwent many changes from its initial creation. Originally, its purpose was to organize, print, and distribute Dr. Peale's sermons. The PCCL had to increase the size of its headquarters in order to keep up with the requests from Christians all over the world for guidance. Architect Roy Van Lent drew up this proposal for the Peale Center for Christian Living. In 1984, Rev. Dr. Norman Vincent Peale would be awarded the Presidential Medal of Freedom by Pres. Ronald Reagan. (Courtesy of the Peale History Center and Library.)

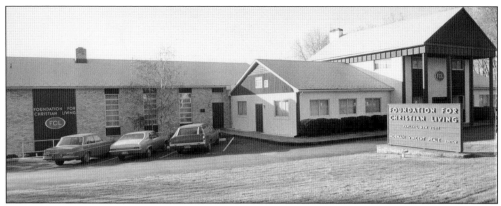

This was the Peales' headquarters for their Foundation for Christian Living. It still serves the Peales' legacy today as the Peale History Center and Library. The library is open to the public and contains more than 6,000 photographs, more than 1,000 books from Dr. Peale's personal library, and original manuscripts by Dr. Peale. (Courtesy of the Peale History Center and Library.)

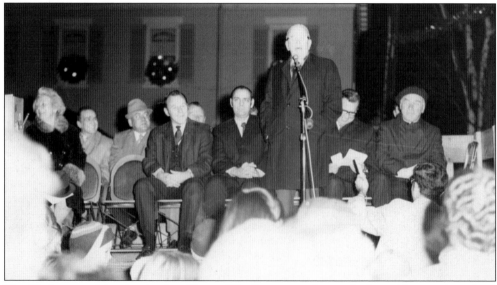

The Christmas celebration in the village of Pawling was a chance for its residents to hear from their spiritual and civic leaders. Businesses would be open late and offer food and drink to all who stopped by. The school's band would play Christmas carols for the town as well. The Christmas celebration is still held today and includes the tree-lighting ceremony and a visit from Santa Claus. Santa visits Pawling the first week in December and listens to children's wishes at the chamber of commerce. From left to right are Ruth Peale, unidentified, Warren Martin, Ross Daniel, Ed Britton, John Lappas, Norman Vincent Peale (standing), Gus Thomes, and Father Storm. (Courtesy of Earl Slocum.)

Clarence "Charlie" Colman was a lifelong resident of Pawling. Born in January 1918, he would live to be 94 years old. Colman was a World War II US Army Air Force veteran, where he worked as an airplane mechanic. He would return from the war and manage the parts department for the DeWitt Bros. dealership. He married Bernice Cole in Pawling on September 9, 1945. He would officially become chief of village police in 1982. Upon his death, Maple Boulevard was renamed in his honor. (Courtesy of the Sheridan family.)

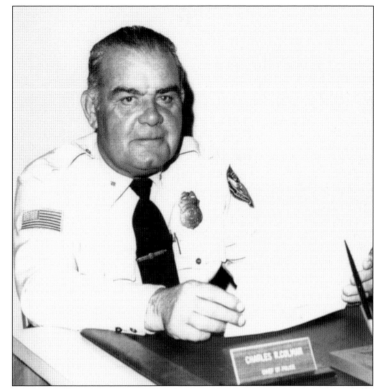

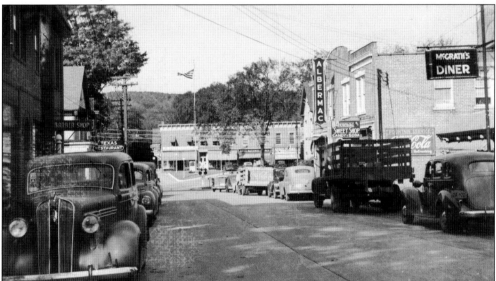

Though an observer could still discern East Main Street from this photograph today, many of the landmarks seen here are still talked about with reverence by the longtime residents of Pawling. The Albermac Theater and Sweet Shop was the place to go on a date. Note the advertisement for a dentist below the McGrath's Diner signage; above a sweet shop is the perfect place for a dentist's office. The Albermac opened on January 20, 1932, and ran until the mid-1970s. The Albermac Theater building and the edifice on the right side of the photograph were remodeled as of 2018. (Courtesy of the Sheridan family.)

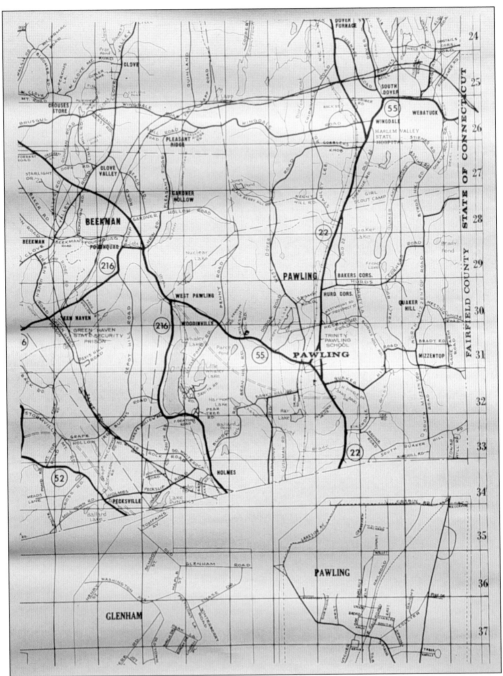

Border disputes were a common occurrence in the early days of the country. Dutchess was not an exemption. Many of the markers dividing land relied upon naturally occurring boundaries (rivers, trees, rocks, and so on). The Oblong Land is a treasured piece of Pawling today; it has become a part of the famous Appalachian Trail. The map shown here is a much more sophisticated piece of cartography than what was available to the area's forebears centuries ago. West Pawling is still listed as a territory, and Trinity-Pawling is the name given to the school on Route 22. This map dates to the second half of the 1900s. (Courtesy of Earl Slocum.)

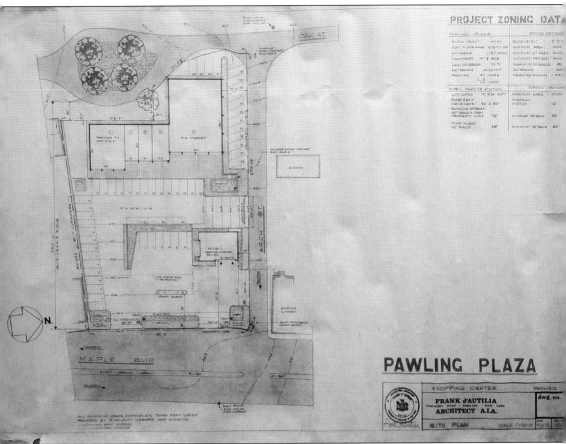

Pawling Plaza would have had parking for 53 cars. This detailed overhead view of Pawling Plaza was designed in March 1972. It had become obvious to the residents of the town that the Dutcher House needed an injection of money to keep it from falling down. Its legacy and provenance have added to the town immeasurably. This was not always the case apparently, as more than a few people believed that a Mobil gas station would have better suited the town. This has become a lesson and a great example of the importance of preserving historical buildings—especially since the Dutcher House has become the de facto symbol of the town. (Courtesy of Earl Slocum.)

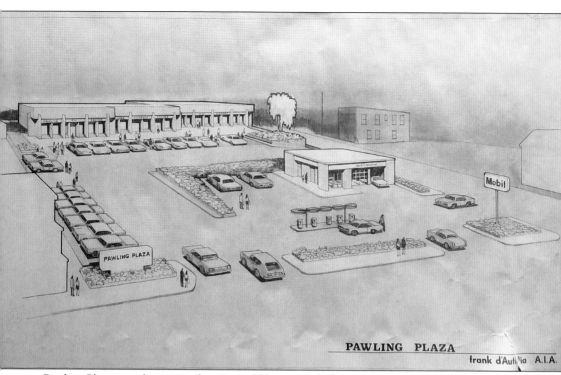

PAWLING PLAZA

frank d'Autilia A.I.A.

Pawling Plaza was almost a reality. It would have stood where the Dutcher House sits on Charles Colman Boulevard. By the 1970s, the Dutcher House had fallen into disrepair. Its fate with the wrecking ball was almost sealed until John Lappas and other local businessmen bought the property and resurrected it. The business represented in this architect's drawing are Joe's Carpets, the Pawling TV Center, and the AG Market. The Mobil gas station and service center would have been front and center, because Pawling loves garages. (Courtesy of Earl Slocum.)

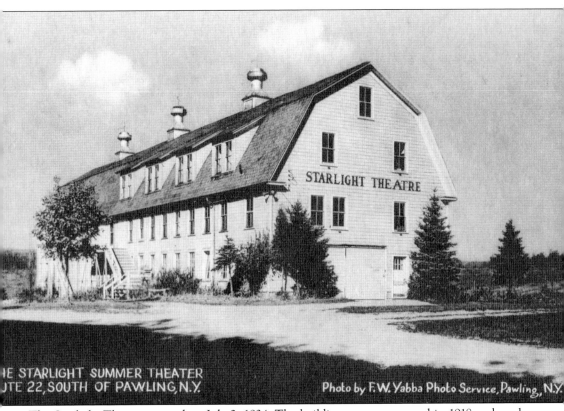

The Starlight Theatre opened on July 2, 1934. The building was constructed in 1918 and used as housing for female farmers—farmerettes as they were known—during World War I. It was leased to Mary Tupper Jones, an actress who performed on Broadway alongside Helen Hayes in the 1925 production of *Caesar and Cleopatra*. The Starlight Theatre closed for a period of time during World War II due to shortages of gasoline and men. It would reopen following the war and then close permanently in 1961. (Courtesy of Nancy Clark Tanner.)

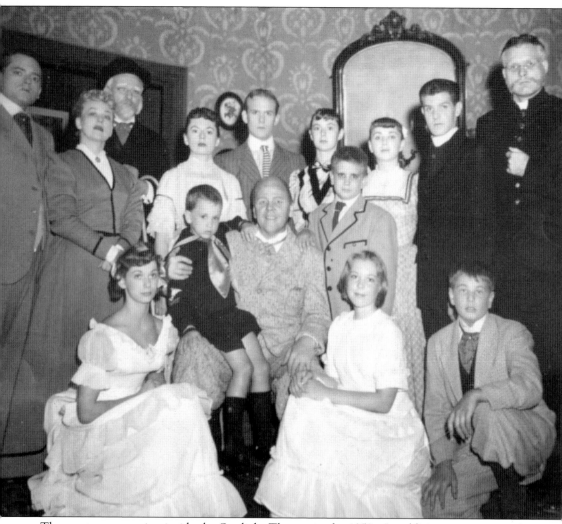

These actors are posing inside the Starlight Theatre in the 1950s. In addition to managing the Starlight Theatre, Jones would also personally direct the plays shown there. She passed away at the age of 86 in 1964. The building was purchased by Stage Door Furniture, which used the space as its showroom. (Courtesy of the Sheridan family.)

The Pawling Shakespeare Club is the oldest literary society dedicated to the Bard in the United States. It has operated continuously for 121 years since it was founded on November 28, 1898, by seven women in the community interested in literature. They first convened in the home of Mrs. Henry Holmes. Membership is limited to 30 individuals, although James Earl Jones, seen here with Margaret Hubert (standing left) and an unidentified woman, enjoys honorary membership in the club. The focus of the group is on Shakespeare, but it has also reviewed the work of other playwrights in the past. The Pawling Shakespeare Club awards an annual scholarship to a graduating senior each year who has displayed an interest in theater. (Courtesy of the Pawling Shakespeare Club.)

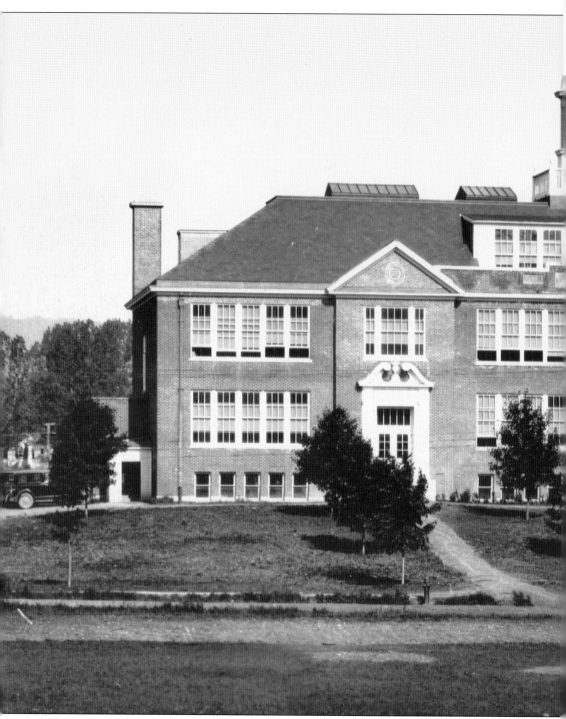

The Pawling High School received many improvements over the years, reflecting a growing town hungry for knowledge. It previously did not sport a cupola, nor the windows built into the roof. It formerly served as a kindergarten-through-twelve building but now only serves kindergarten

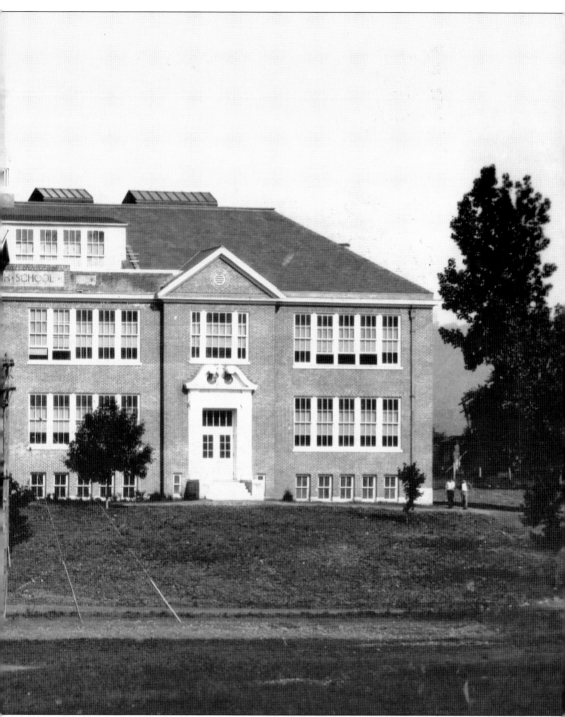

through the fourth grade. The current high school on Wagner Drive would not open until 1968. (Courtesy of the Akin Free Library.)

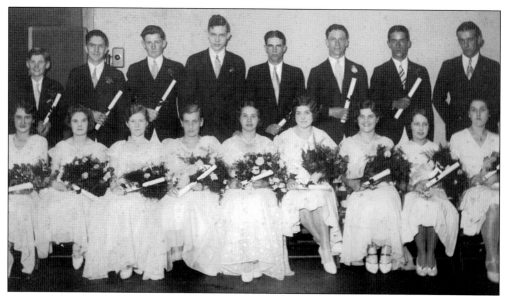

The graduating class of Pawling in 1930 had a record number of students. Here, 16 students earned their diplomas and posed with the principal, seen at far right in the back row. Phil Sheridan is standing to the left of Principal Bonewitz, and the last girl on the right is Muriel Penny Hasler. (Courtesy of the Sheridan family.)

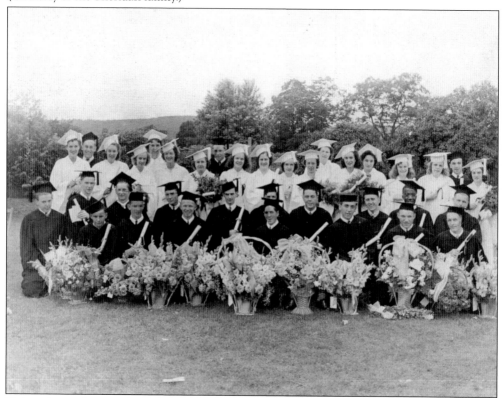

This is the graduating class of Pawling in 1942. Toosie Flanagan is in the back row, fourth from the left. (Courtesy of the Sheridan family.)

Pawling and its neighbor Dover Plains have always had a rivalry in sporting events. This home varsity game against the Dover Dragons was played in early 1965. Pawling players from left to right are Andy Herzing, Mike Ragnetti, Mike Cunningham (No. 25), and Gregg Sheridan in midair. (Courtesy of the Sheridan family.)

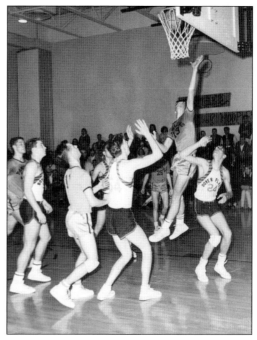

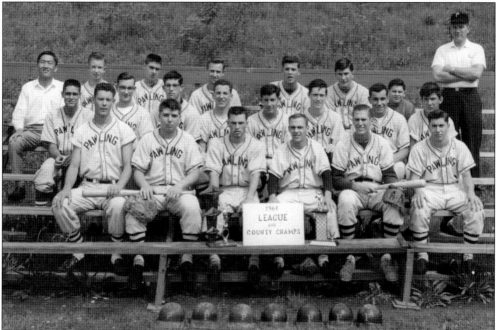

The Dutchess County champions of 1964 are seen here on the playing field outside the high school on Wagner Drive. Pictured are, from left to right, (first row) Andy Herzing, Charlie Masseo, Rodney Smith, Billy Chilcutt, Johnny Paugh, and Ashley Cunningham; (second row) Robert Bourdon, Clark Dalzell, Gregg Sheridan, Butch Anderson, Greg Hinkley, Mike Cunningham, Ron Russo, and Phil Bauer; (third row) manager Steve Chow, John Thomes, Phil Viehl, Mike Ragnetti, Billy Miller, Joe Kelly, manager Bobby Davis, and coach Brud Coombs. (Courtesy of the Sheridan family.)

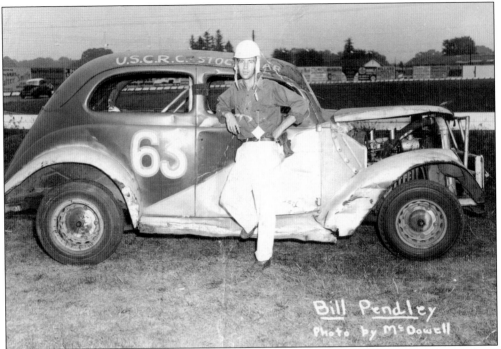

Bill Pendley was a resident of Holmes and involved with racing. He would travel with his stock car to the Poughkeepsie Raceway. (Courtesy of the Historical Society of Quaker Hill and Pawling.)

The Miss Pawling Pageant was a contest put on by the Pawling Volunteer Fire Department. The contest was started in 1962 and was very popular for many years. The Pawling Volunteer Fire Department would select a queen and her court for the duration of the homecoming parade. Pictured here is the queen of 1962, Susan Cowlich. She is accompanied by her royal court Pam Slawson (left) and Jean Mercilliot. (Courtesy of the Sheridan family.)

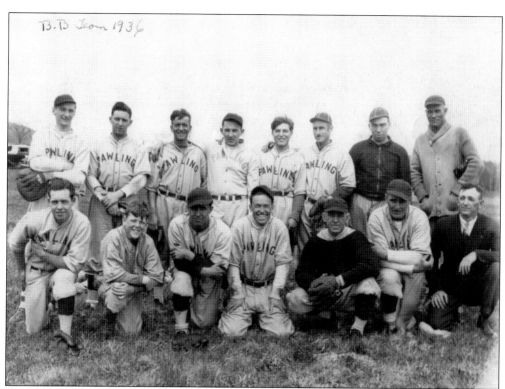

Pawling, like many other small towns in the area, had a town baseball team. It would travel along the Harlem Line and play other towns, such as Dover, Brewster, Carmel, and Poughquag. Pictured are, from left to right, (kneeling) ? Riley, Artie Cole, unidentified, Wayle Osborne (with a great smile), E. Munn Slocum (in the black sweater), Harold Mace, and Coach Lascesky (in the suit); (standing) Lascesky's son, four unidentified, Lynn Mace, Bill Greene, and George Utter. (Courtesy of the Sheridan family.)

One of the most memorable athletic performances in Pawling history occurred on November 12, 1966. The Pawling Tigers hosted Roeliff-Jansen High School of Hillsdale, New York, on a field soaked from two straight days of rain. In the final game of Phil Bauer's (10) senior year (the same year the Tigers first achieved the league championship), his performance in the first half remains the standard for all past and future Tigers to be measured against. In the first quarter alone, he amassed three touchdowns, including a 70-yard reception. In the second quarter, Phil Bauer managed another 55-yard touchdown reception and followed it with a 70-yard pick-six on defense. His extra-point kick after that finished his day on offense, as his second half was limited to play on defense only. The 44-0 Tiger win was celebrated with exuberant mudslides at midfield. (Courtesy of the Sheridan family.)

The Book Cove first opened for business on Arch Street on Thanksgiving weekend 1976. It was the vision on Nancy Clark Tanner, who was the store's first proprietor. This interior photograph of the 800-square-foot location includes, from left to right, Nancy C. Tanner, invaluable Paul D. Travers on the phone, and Beth Tanner. (Courtesy of the Book Cove.)

Nancy Clark Tanner and her grandson Nathan Tanner are seen here inside the current location of the Book Cove around Christmas 2018. He began working in his grandmother's bookstore while also attending nearby Trinity-Pawling. (Courtesy of the Book Cove.)

The great Elizabeth "Betty" Sheridan Gallagher is seen here in 1998 standing outside the Annex Florist on the night of the annual tree-lighting ceremony. Elizabeth was born in May 1935, the daughter of James and Teresa Sheridan. Betty is remembered for her unwavering service to Pawling Elementary School, having started teaching in 1970 and continuing to inspire kindergartners for 39 years. The playground outside her former classroom has been named after her so that she may continue to serve all the future students of Pawling schools. (Courtesy of Ed Mahaffey.)

Charlotte Whaley was a legend in her own time. She was born on August 20, 1919, and passed away on May 19, 2019. She was a member of the graduating class of Pawling in 1935. She would work at the Pawling Savings Bank for 43 years. Whaley was a prominent member of the Pawling Ladies Auxiliary and supported her town whenever she heard the call. For Pawling, she is and will always be an irreplaceable treasure. She is seen here in her home with her beloved Butterscotch on October 4, 2018. (Courtesy of Max Weber.)

BIBLIOGRAPHY

Carmer, Carl. *Rebellion at Quaker Hill*. Toronto, ON: The John C. Winston Company, 1954.

Feron, Myrna. *Town of Pawling 200 Years*. Charlotte, NC: Delmar Company, 1987.

Grogan, Louis V. *The Coming of the New York & Harlem Railroad*. Pawling, NY: 1989.

Kendrick, Alexander. *Prime Time*. Boston, MA: Little, Brown and Company, 1969.

Noonan, Troup. *A Pride of Fighting Gentlemen*. Chapel Hill, NC: Heritage Histories, 2006.

Smith, James. *History of Duchess County*. Syracuse, NY: D. Mason & Co. 1882.

Smith, Richard Norton. *Thomas E. Dewey and His Times*. New York, NY: Simon and Schuster, 1982.

Stephens, Mitchell. *The Voice of America*. New York, NY: St. Martin's Press, 2017.

DISCOVER THOUSANDS OF LOCAL HISTORY BOOKS FEATURING MILLIONS OF VINTAGE IMAGES

Arcadia Publishing, the leading local history publisher in the United States, is committed to making history accessible and meaningful through publishing books that celebrate and preserve the heritage of America's people and places.

Find more books like this at
www.arcadiapublishing.com

Search for your hometown history, your old stomping grounds, and even your favorite sports team.